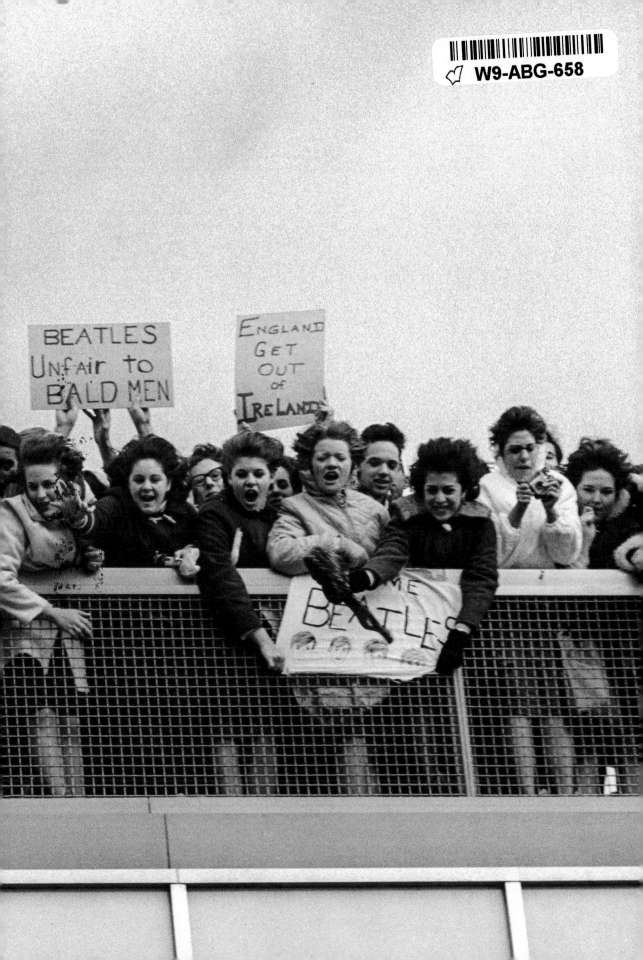

ON
FEBRUARY 7,
1964,
THE BEATLES
BOARDED
PAN AM
FLIGHT 101
TO NEW YORK.
IT WAS THE
BAND'S FIRST
TRIP TO
THE UNITED
STATES.

BILL EPPRIDGE
WAS AT JFK TO
PHOTOGRAPH
THEIR ARRIVAL,
AND HE
DOCUMENTED
THE SIX
DAYS THAT
FOLLOWED.

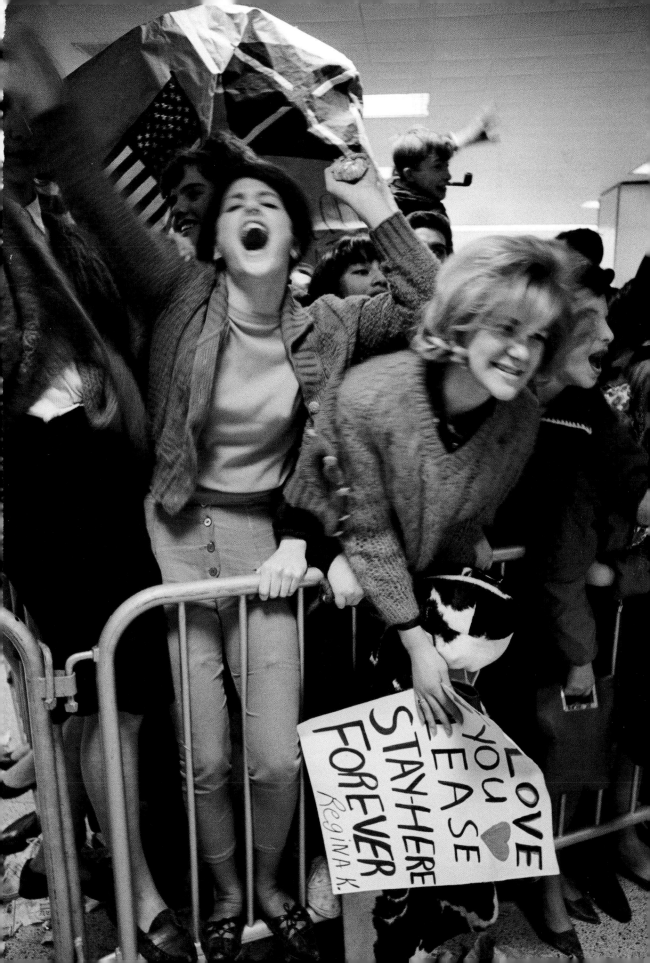

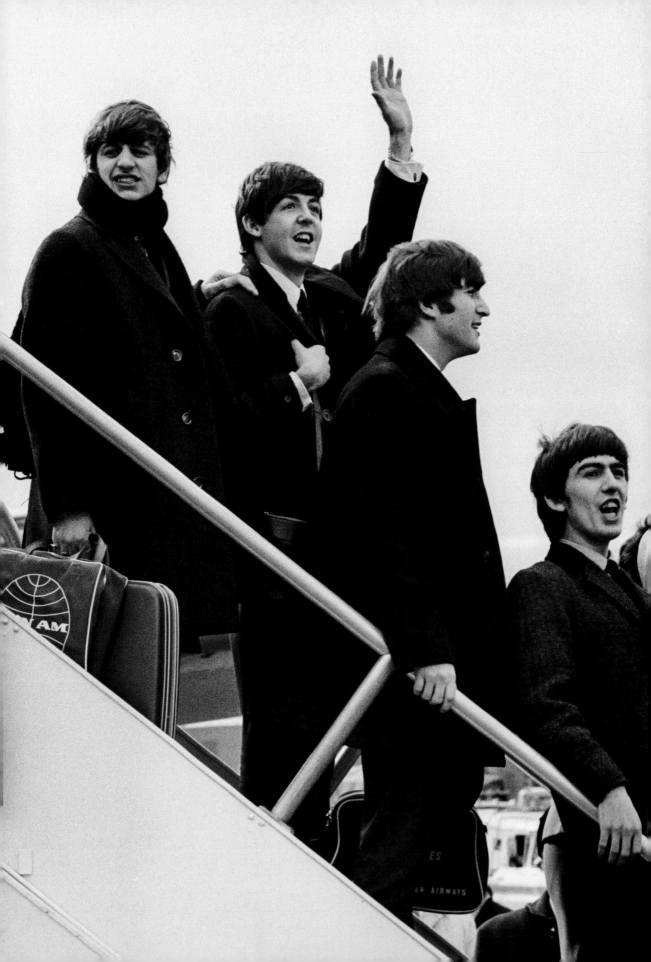

# THE BEATLES
## SIX DAYS THAT
## CHANGED
## THE WORLD
## FEBRUARY 1964

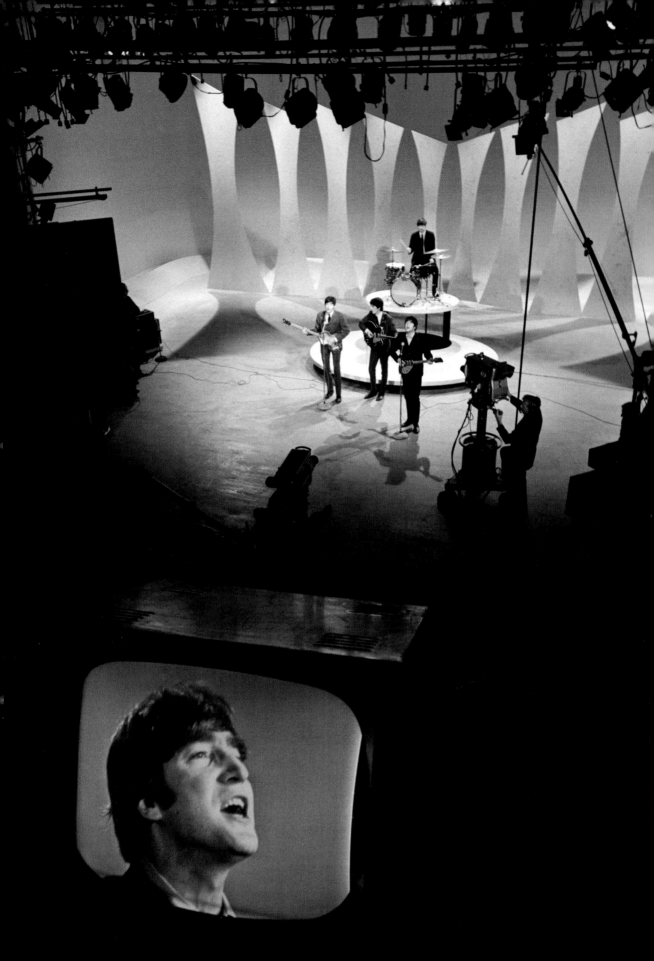

# THE BEATLES
## SIX DAYS THAT CHANGED THE WORLD FEBRUARY 1964

**PHOTOGRAPHY BY BILL EPPRIDGE**

**INTRODUCTION BY RANKIN**

**EDITED BY ADRIENNE AURICHIO & DANIEL MELAMUD**

*RIZZOLI*
NEW YORK

New York · Paris · London · Milan

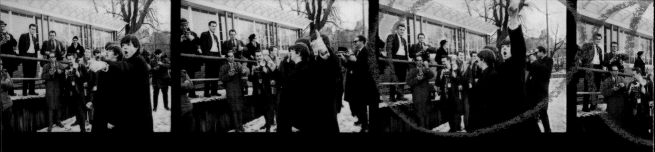
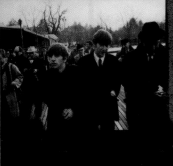
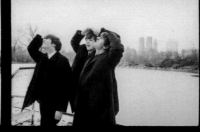

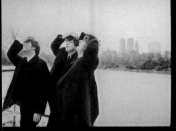

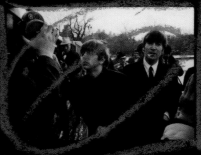
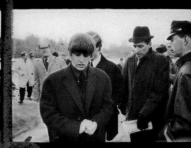
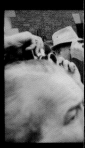

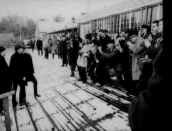
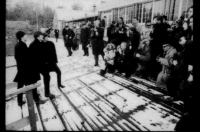
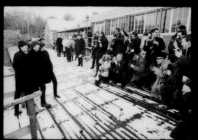

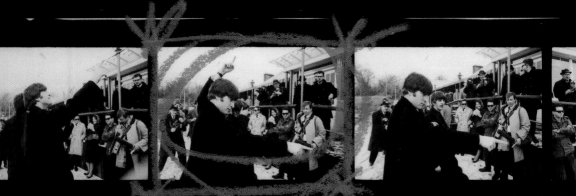

# INTRODUCTION
## BY RANKIN

Good photographers have to love their subject. By this I don't mean the people in front of your lens—not the hot young girls or boys—but instead I mean the higher subject. In Bill Eppridge's case, that is humanity.

Most people assume that documentary photographers are tough. They go on assignments, putting their lives and sanity at risk. The contradiction is that to be any good at taking these kinds of images, you actually have to be incredibly sensitive. You may need tenacity and strength to "go there," but you can't do it without soul. Bill Eppridge is one of those guys with the deepest of souls.

Bill was one of the great *Life* magazine photojournalists. His work enthralled, saddened, and, in a lot of ways, summed up a generation. Back in the 1960s, it must have been exhilarating stuff. These types of images were new and fresh, and Bill's were among the best of the best.

*Life* photographers would take their cameras and embed themselves into pockets of society. They integrated, assimilated, and became a part of the fabric of other people's social groups for months on end, and thus they made themselves invisible. From that privileged and fragile position, they captured views that were privy only to a very few, and pushed them out into the wider world. The final result may possibly have been only a few pages in the magazine—but what amazing pages they were. Back then, *Life* magazine was the lens through which America viewed itself—before the omnipresence of TV, the Internet, and twenty-four-hour news. The magazine's content was the pulse of America's heartbeat, and *Life* photographers sculpted and focused this window onto a nation.

So when Bill went to photograph the Beatles that day in 1964, he went with quite a responsibility on his shoulders. It's so easy to say "right place, right time," but when you're shooting for *Life* and you're on assignment, I'm sure that

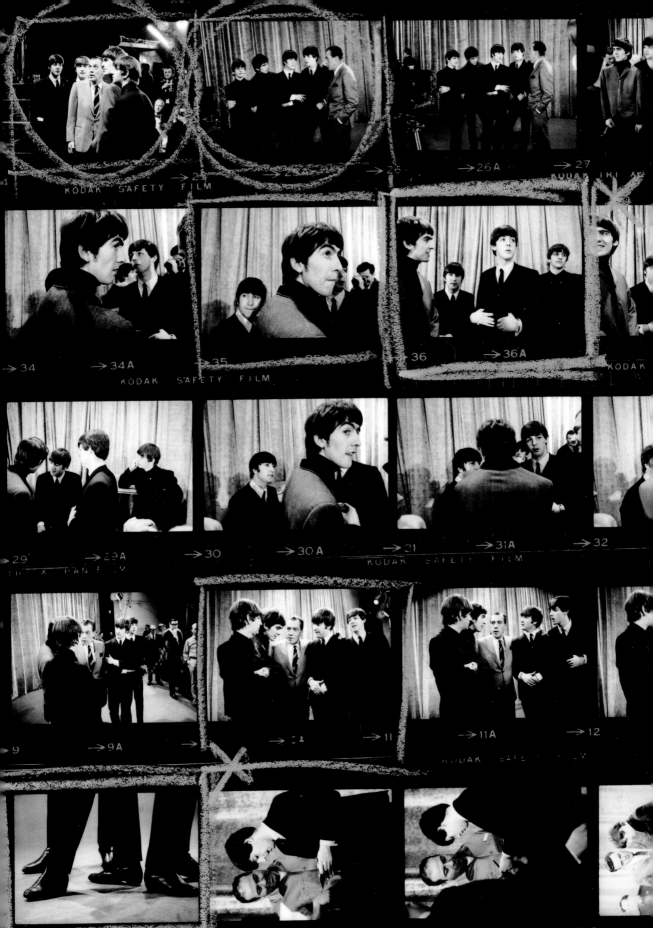

meant the "right" set of images had better come back or there would be hell to pay. Expectations were high—it was no place for luck.

That kind of pressure is pretty heady stuff. I've only had to face it a few times and your "decisive moment" eye needs to be sharp, trained, and unwavering. When I look at Bill's images here I see a *Life* photographer in his prime shooting everything that he saw in the best way he knew how.

Leafing through *The Beatles: Six Days that Changed the World* is like looking at an incredible set of contact sheets, seeing the Beatles through the eyes of one of the best photojournalists working at that time. You see how Bill was looking for every angle, every moment that could encapsulate the feeling that America was sensing for these four young guys, and serve it back to them on the pages of their own "Life."

An image I particularly like in the book is the picture of the guy with all of the "Beetles" badges—trying to make a quick dollar in the biggest consumer society in the world, but getting the name of the band so wrong! It's like a magnifying glass on naivety—and an amusing portrayal of how fast the world was changing.

Bill's images are more than just that "decisive moment" that he was clearly so proficient at capturing. His images touch me. I feel as though I'm there—transported back nearly fifty years to a smoky train carriage, where you can see the look of excitement in every eye, in every image, on every page. More than anything, you feel Bill's excitement at being there. Part of the party but intentionally invisible. You see how infectious those "boys" were and how the world around them looked like it needed shaking up in comparison.

A brilliant younger photographer once described Bill's image of the Bobby Kennedy assassination as being "the image that ended the '60s." What I think he meant was that the image signified the end of optimism, of people's belief that they could change the world. But only a photographer who believed they could change the world could take an image like that. That was Bill Eppridge.

This book taps into Bill's mind, for a fleeting six days, when a group of four boys and a photographer made it feel and look as though they really could change the world. It only makes me wish I'd been there too.

London, June 2013

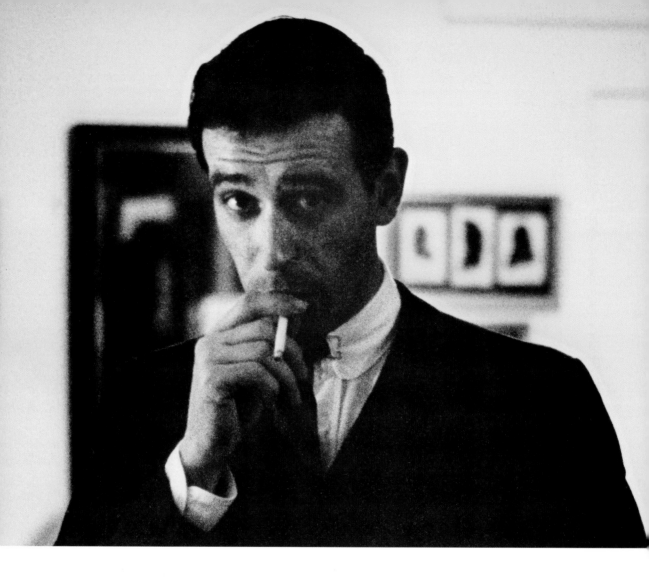

# FOREWORD BY BILL EPPRIDGE

I was in the *Life* magazine offices early in the morning of February 7, 1964. It was nearly eight o'clock and Dick Pollard, the director of photography, was the only other person on the floor. As I was walking down the hall, he saw me and called out, "Eppridge, what are you doing today? You want to shoot something for me? We've got a bunch of crazy Brit musicians coming to town this afternoon—the Beatles. Do you know anything about them?"

I answered back, "Nothing. Yes. And no."

The only news story I had ever seen about the Beatles was from a *Life* issue, photographed in England, a month or so earlier. I remembered a picture of teen-age girls in a state of frenzy. The magazine often sent me out on assignments with very little information on my subject and this was no different. The editors wanted to see the story through my eyes, not based on what reporters might have written before. They didn't want my vision clouded by other opinions.

I had just returned from photographing a story on hate groups and fear mongers in the South including the Grand Wizard of the United Klans of America, Robert Shelton. After I had taken his picture I accepted Shelton's offer of a seat aboard a small plane the Klan had chartered from Tuscaloosa to Montgomery. On the way to the airport I changed my mind and decided to drive the distance.

I never told Shelton that I would not be on the flight. When I arrived at a *Life* reporters' hotel room in Montgomery a few hours later, I learned the plane had crashed, and I had been reported missing and presumed dead. After that, the Beatles seemed like a welcome diversion.

In the three years that I had been shooting for *Life* and the time before that for *National Geographic*, I had worked in twenty-two countries; I'd seen riots and a couple of revolutions. I saw that the world was changing in the 1960s. There were serious situations in the South with civil rights. Fidel Castro was affecting our country's involvement in Latin American politics. The Cold War with the Soviet Union was escalating, and there was a great fear of nuclear weapons. At that time, I would never have believed that four musicians could have had such an impact.

Pollard told me to go to the airport right away—their flight was arriving in a few hours. I grabbed several cameras and took a cab to Kennedy airport. I arrived before noon and found New York press photographers, reporters, and television crews staking out their positions.

Police were gathering inside the Pan Am terminal, and teenagers were multiplying. It looked like a few thousand of them, and barricades had been put in place to keep them contained. There was something different about the excitement level—the kids knew it, and they were part of it.

Airport personnel had provided elevated rolling stairs for the press photographers to use but I preferred a position on the ground. When the Pan Am jet finally taxied into the gate at 1:20 p.m., stairs were rolled up to the door, and out walked a Pan Am stewardess—bright, young, and pretty. Right behind her were four young gentlemen in coats and ties. Not exactly what I was expecting. I waited for a quartet of ragged rock musicians to emerge, but photographed *these* four, whoever they were.

I quickly turned around to look back at the photographers on the stairs. They all had the same expression on their faces—disbelief at what had emerged from the plane: young men who acted normally, looked happy to be there, and seemed pleased with the reception greeting them. Their hair was longer than most, but that was the only thing that set them apart.

The teenagers, thousands of them, went wild. Many were on the top floor of the terminal, outside, and what had been loud noise in the background suddenly rose in volume to a roar of piercing screams. The Beatles acknowledged all this with smiles and waves. Their press conference in the Pan Am lounge was one of the funniest I have ever been to. I liked these guys immediately.

I called Pollard right after that, and told him that I wanted to stay with the group for the next few days. I really didn't have any idea of what was going to happen, or where they were going. I had no itinerary. Maybe the reporter who was with me did, but I can't remember. With my *Life* credential, I was accepted into the inner party. Shortly after, Ringo Starr turned to me and said, "All right, Mr. Life Magazine, what can we do for you?"

"Nothing," I said, "not one single thing. Just be you and I'll turn invisible. I won't ask you to do a thing."

I shot ninety rolls of film. *Life* published only four of the images in 1964. I had no time to look at the negatives or the contact sheets. After I finished the story on February 12, I was given a contract with *Life* and assigned to the Chicago bureau. At some point I asked to see the film, but my negatives were missing or misplaced in the office. The film turned up seven or eight years later, and I finally got to relive what had happened over those few days I spent with them. By then the Beatles were no longer together but they had caused a revolution and were significant in ways that no one could have imagined at the time.

New York, June 2013

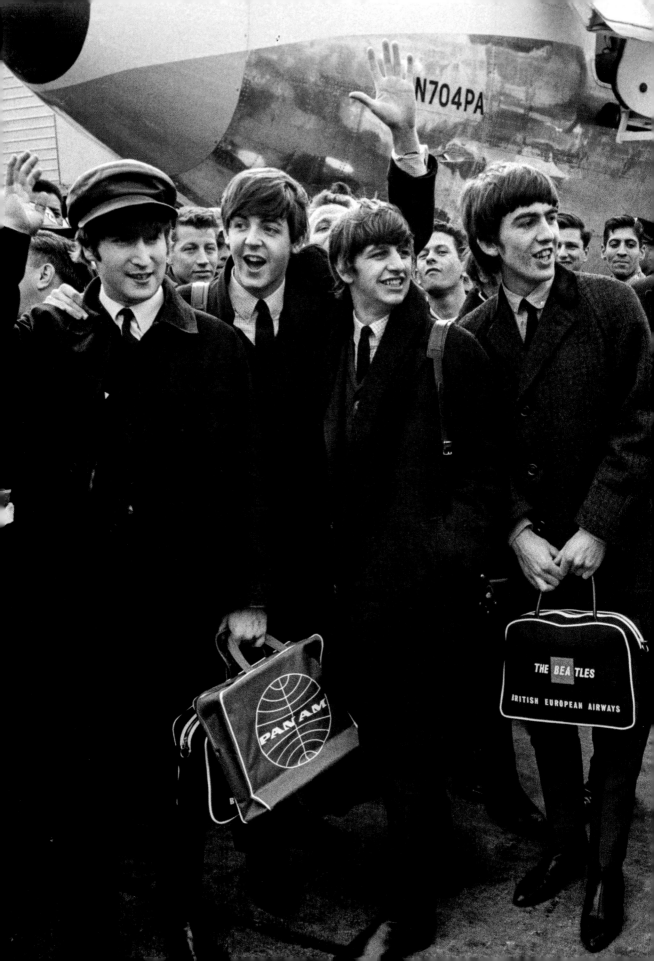

# DAY 1

The Beatles land at John F. Kennedy International Airport on Pan Am Flight 101 at 1:20 p.m., Friday, February 7, 1964. Over 3,000 fans gathered to greet them.

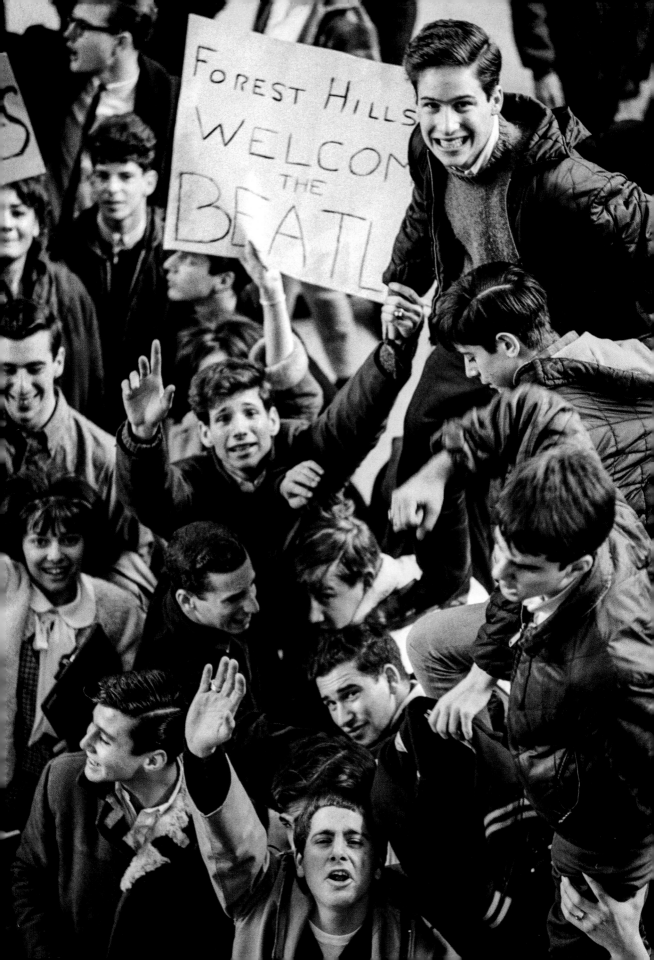

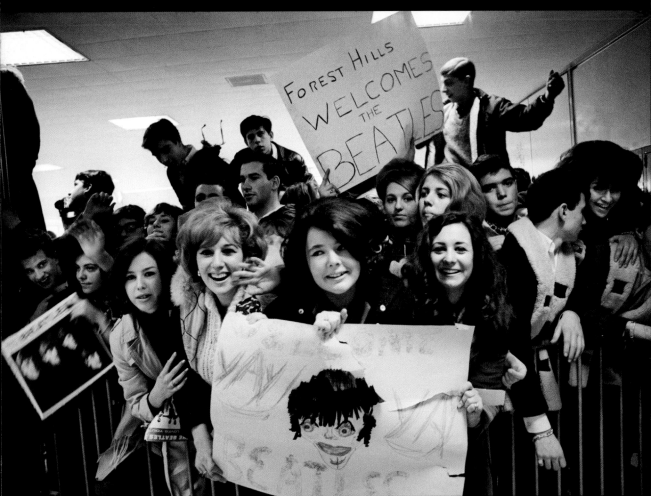

The Beatles' first
American press
conference, held
at JKF airport.

Overleaf: The
band's press
officer, Brian
Sommerville,
stands to Paul's
right, and Murray
the K, a DJ and
vocal supporter
of the Beatles
from WINS
radio station in
New York City,
crouches below,
his hand on
the platform.

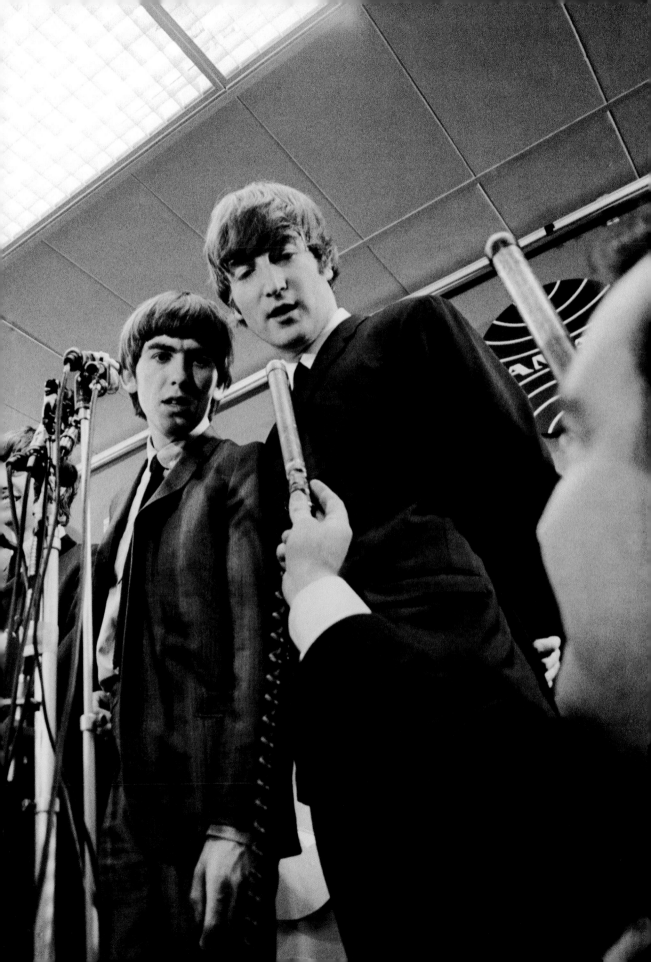

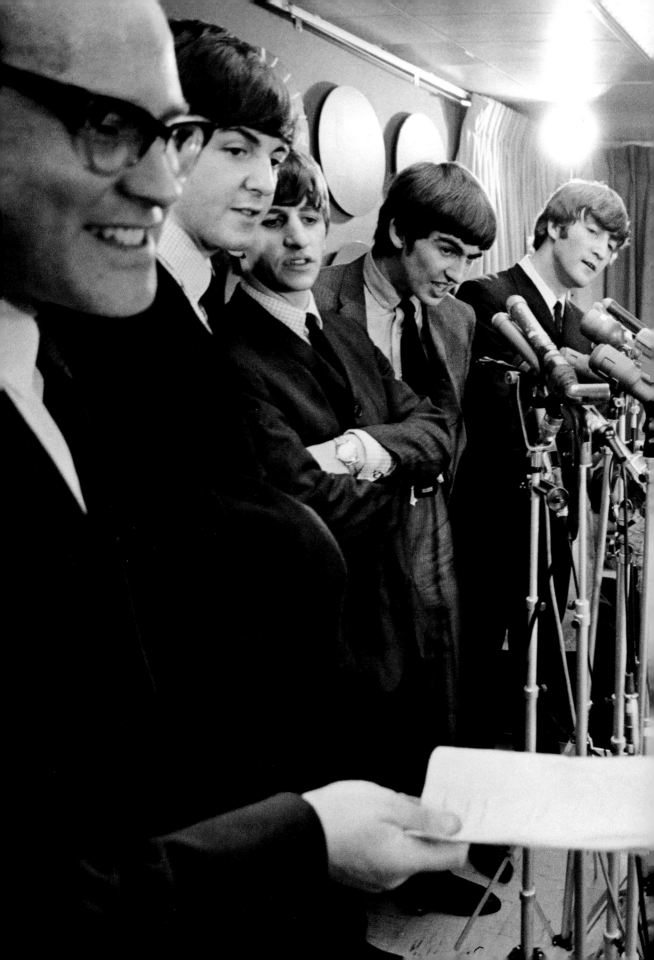

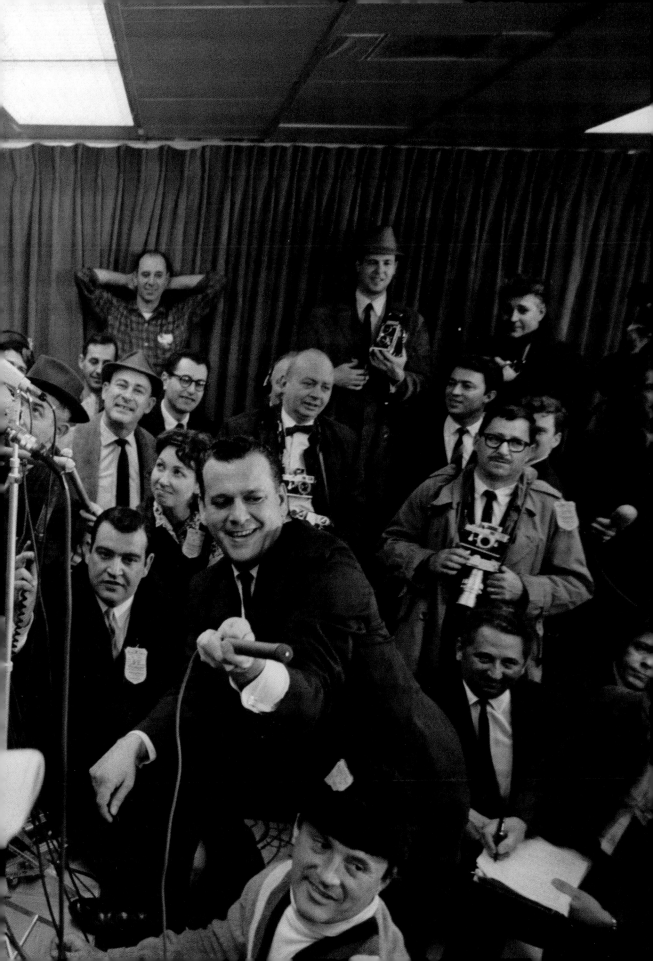

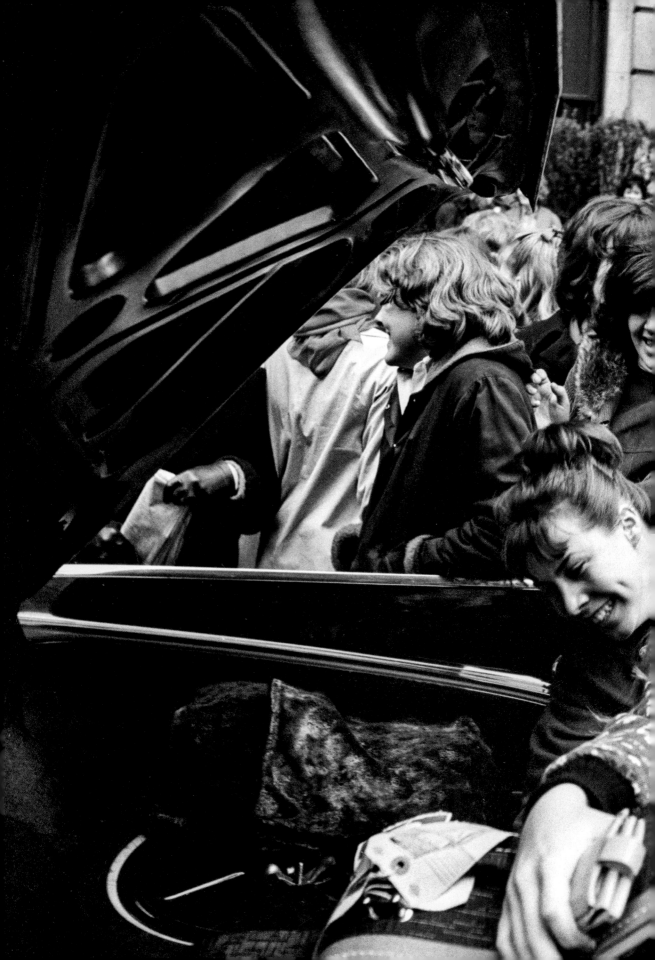

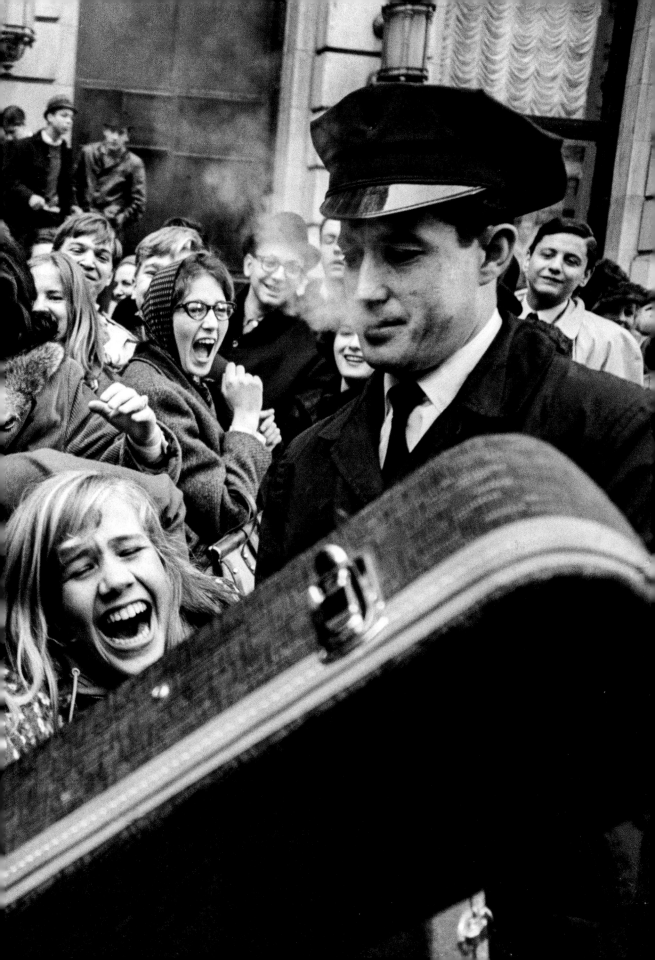

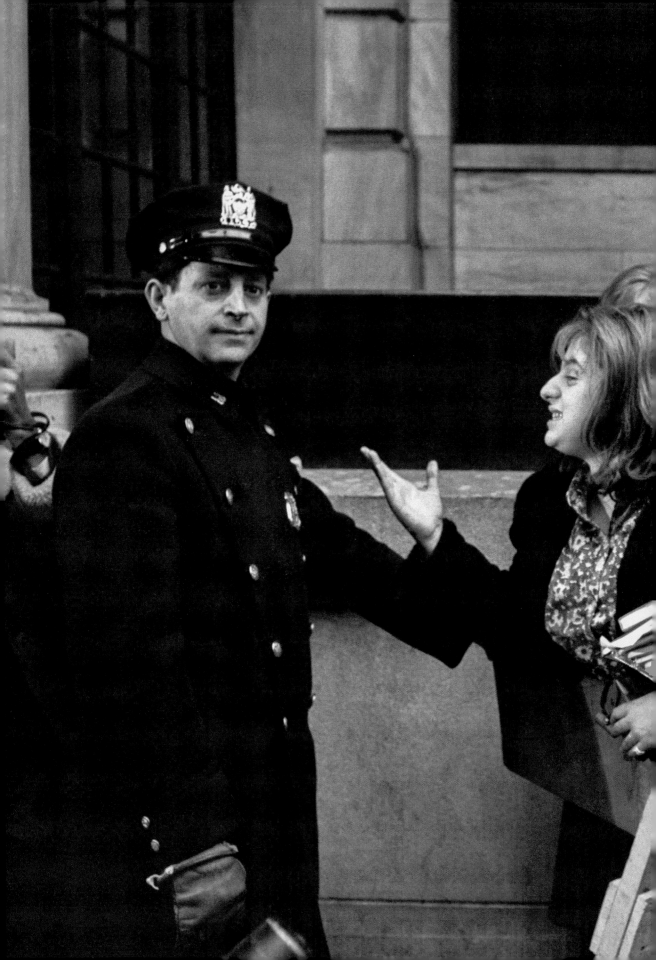

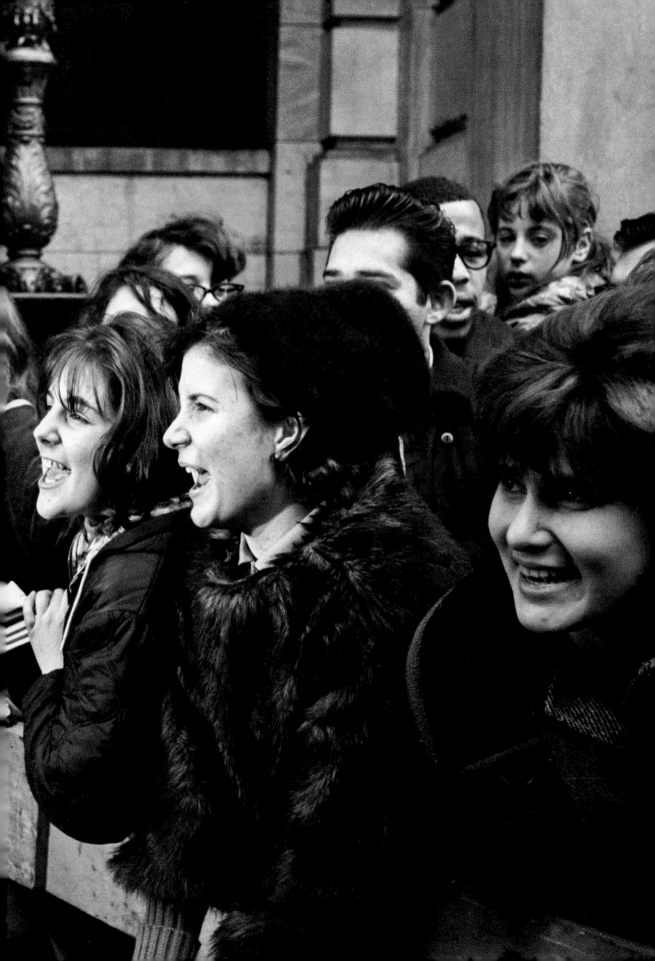

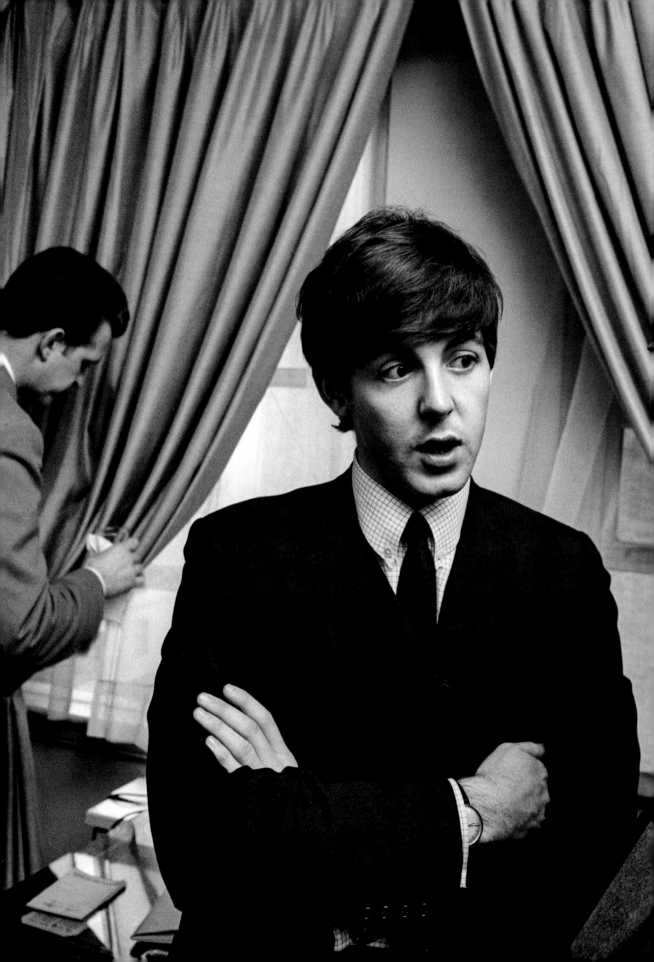

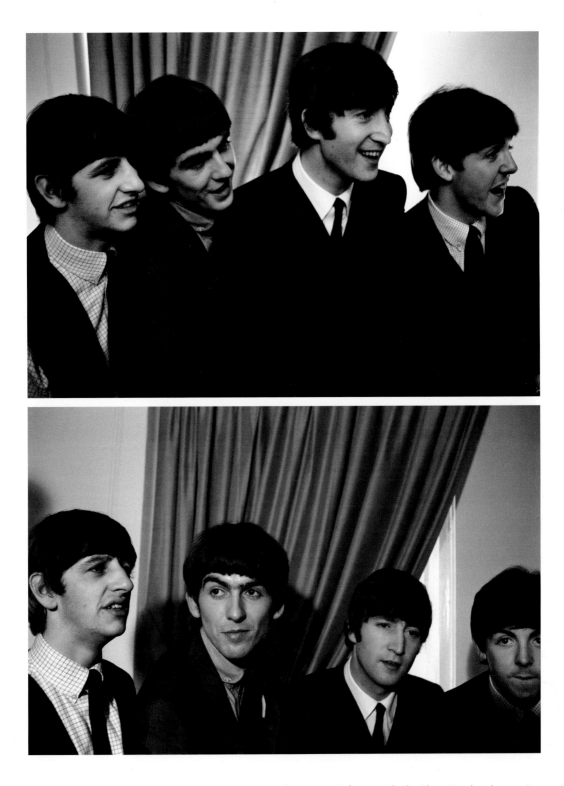

Preceding pages: A fan outside the Plaza Hotel grabs a guitar case belonging to the Beatles moments after the group was hurried inside; fans plead with a policeman for a chance to see the Beatles, who had just entered the hotel. The band occupied the Presidential Suite on the twelfth floor, having checked in individually under their real names (Mr. J. Lennon, Mr. P. McCartney, Mr. G. Harrison, and Mr. R. Starkey).

Above: Posing for the press and moments afterward.

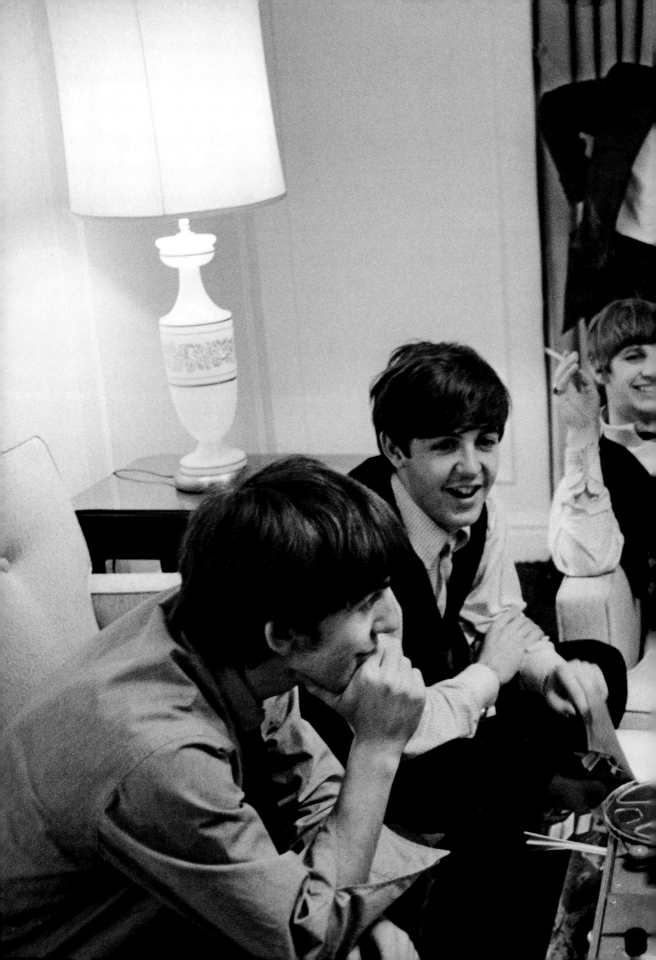

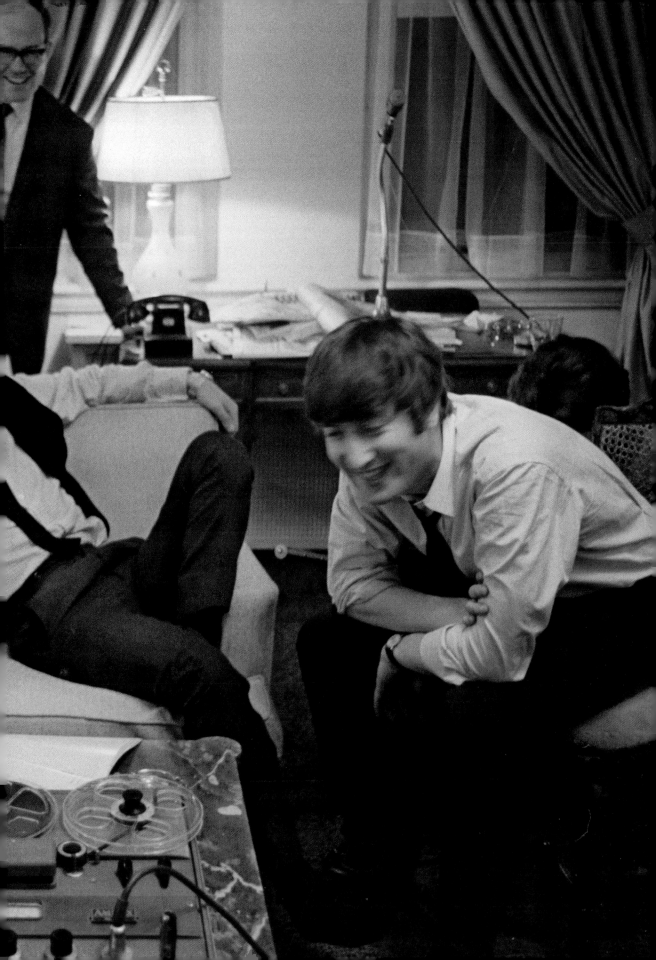

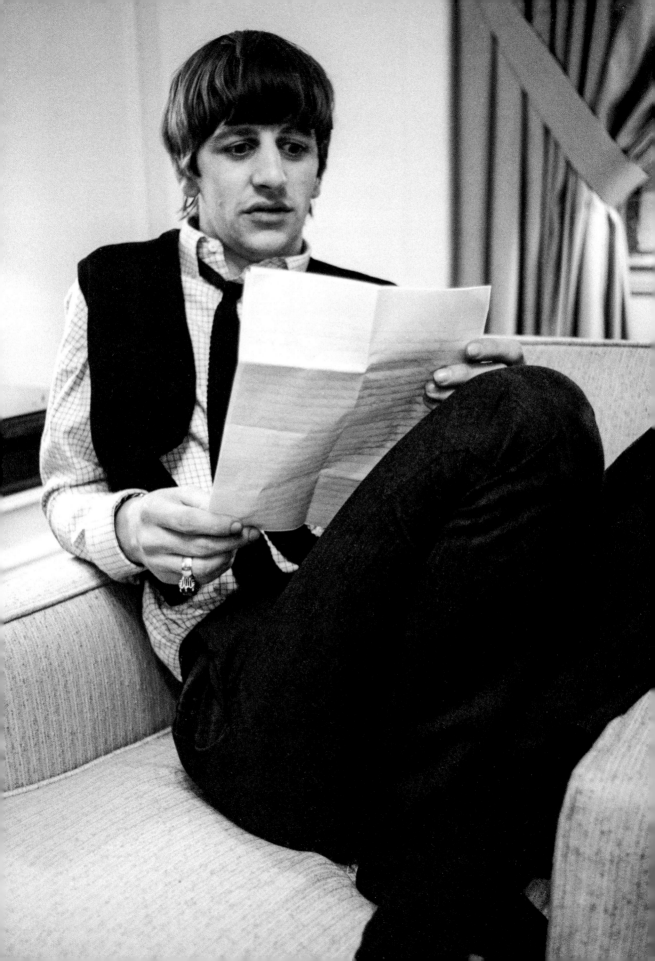

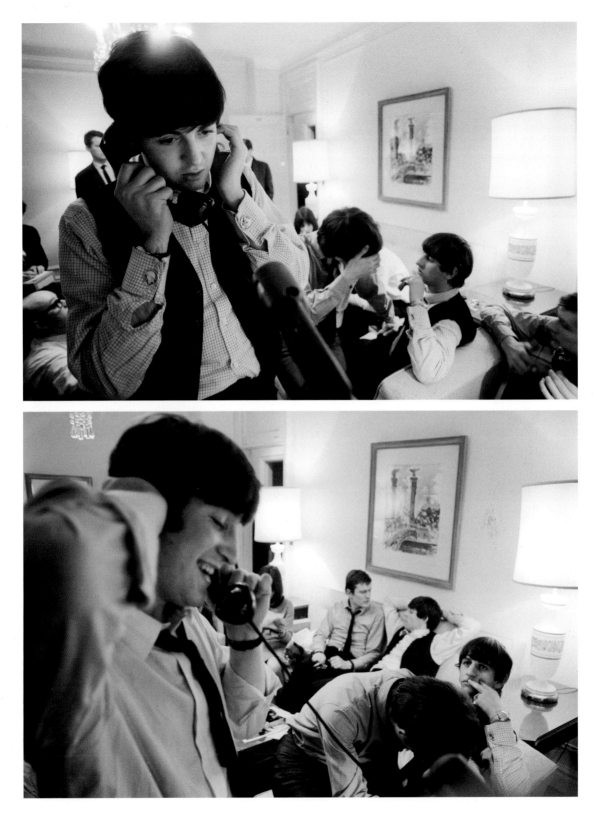

Preceding pages: The Beatles and their press officer, Brian Sommerville, listen to a recent BBC radio interview on a reel-to-reel tape machine.

Above: Paul and John being interviewed over the phone.

Opposite and following pages: The band unwinds in their hotel suite.

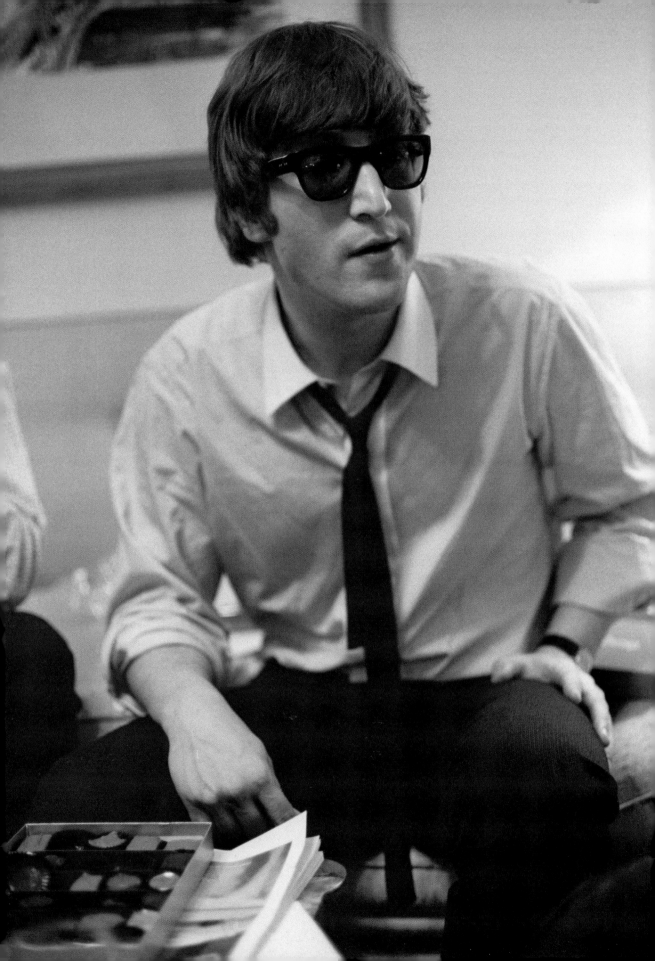

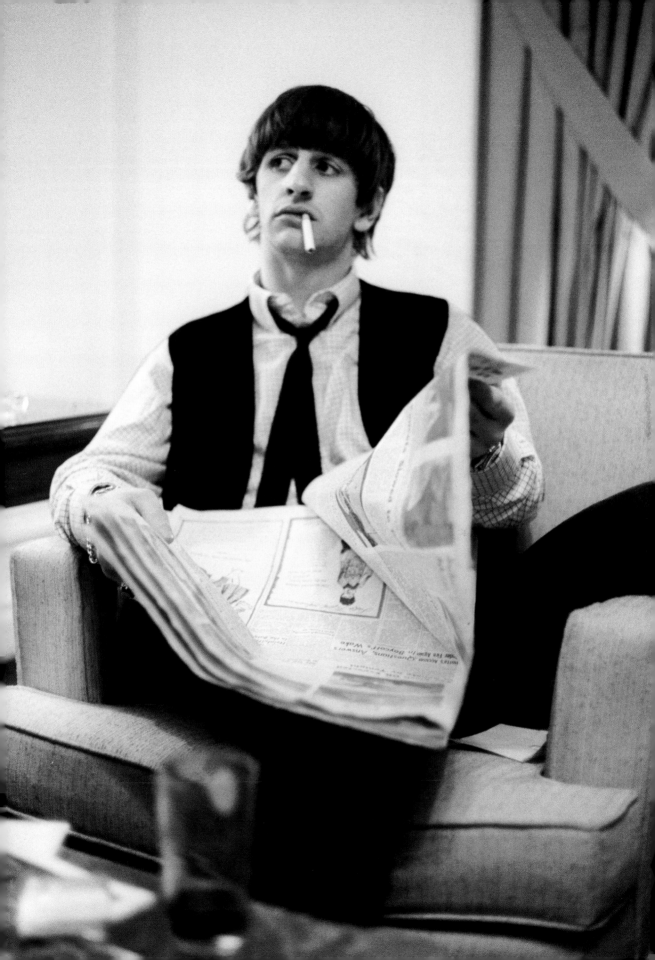

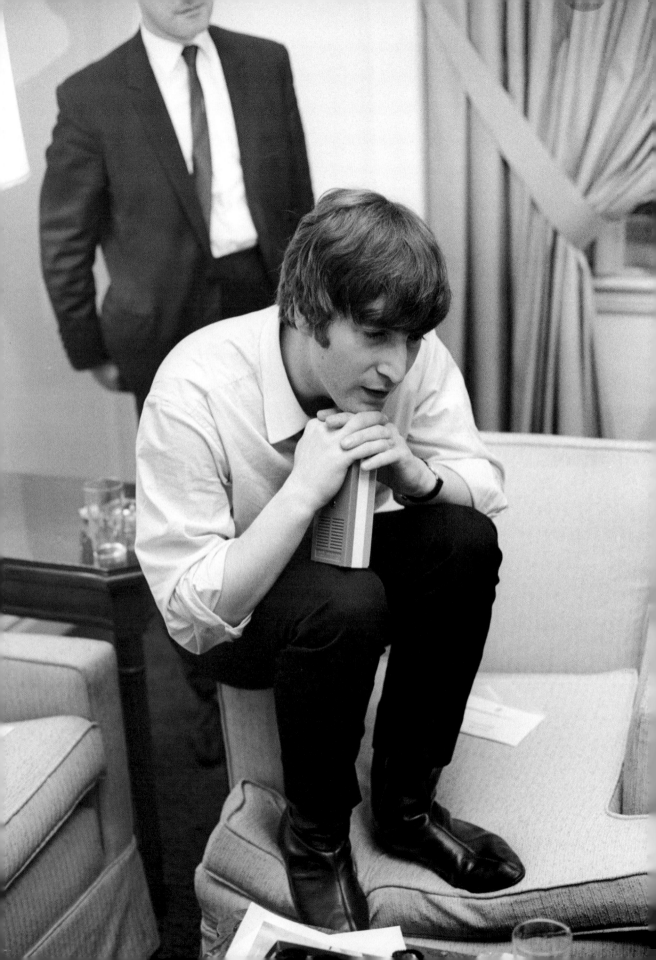

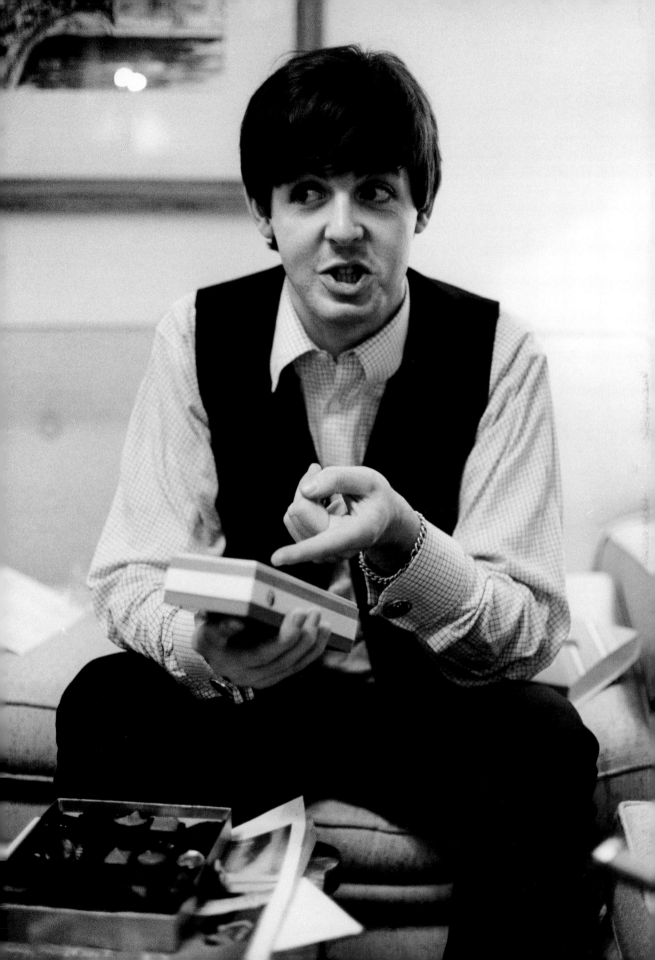

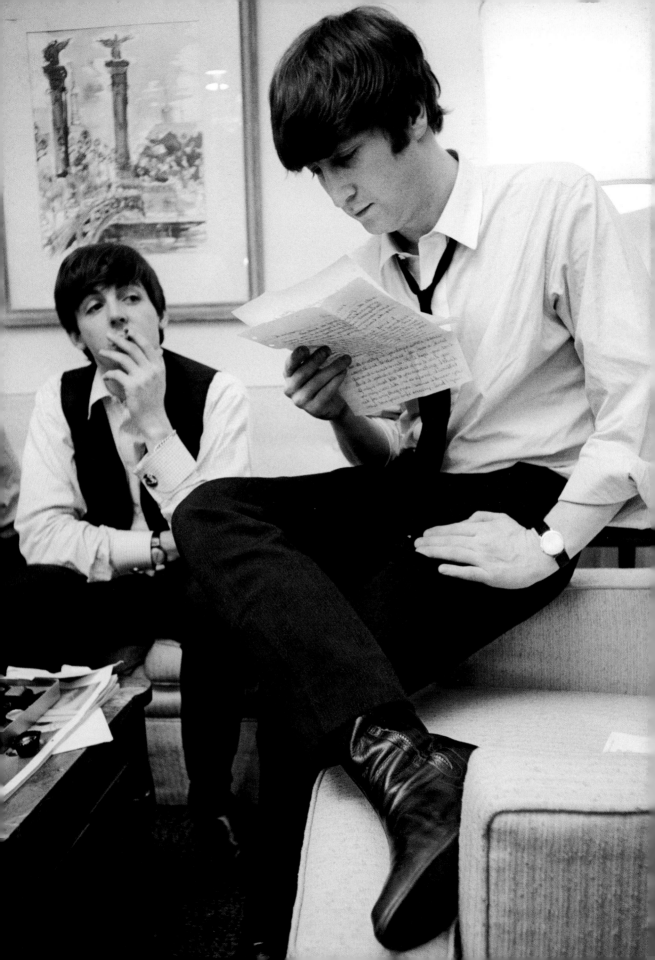

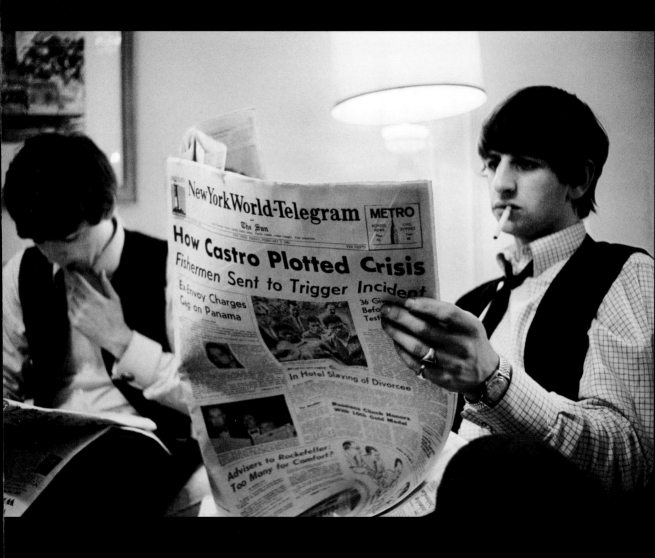

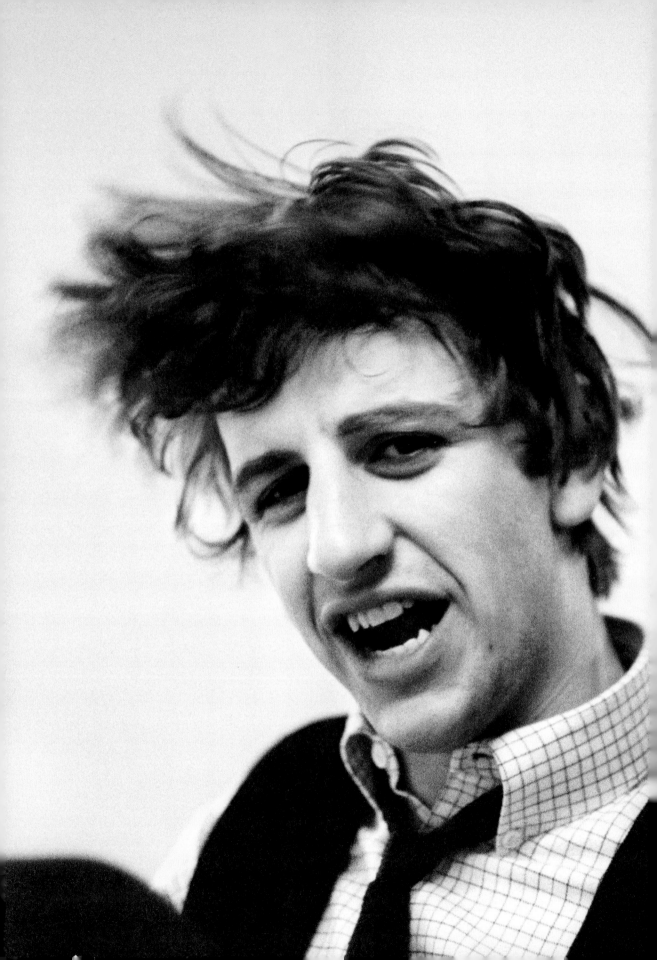

Overleaf: Paul
and Ringo
watching Walter
Cronkite's
report of their
arrival at JFK
airport on the
CBS evening
news.

Following
pages: New
York City police
gather outside
the Plaza Hotel
in the evening.

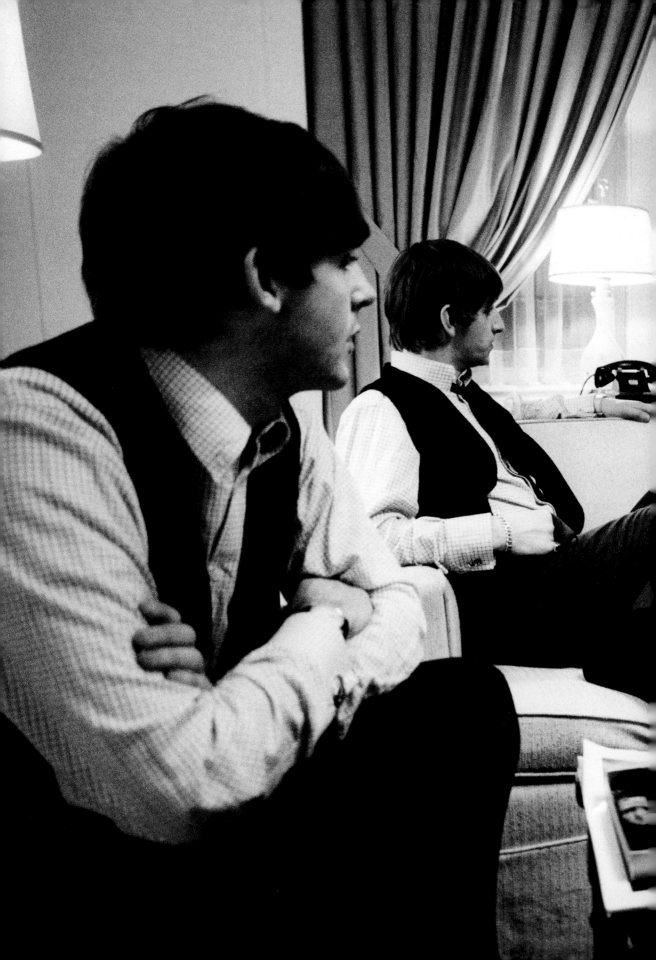

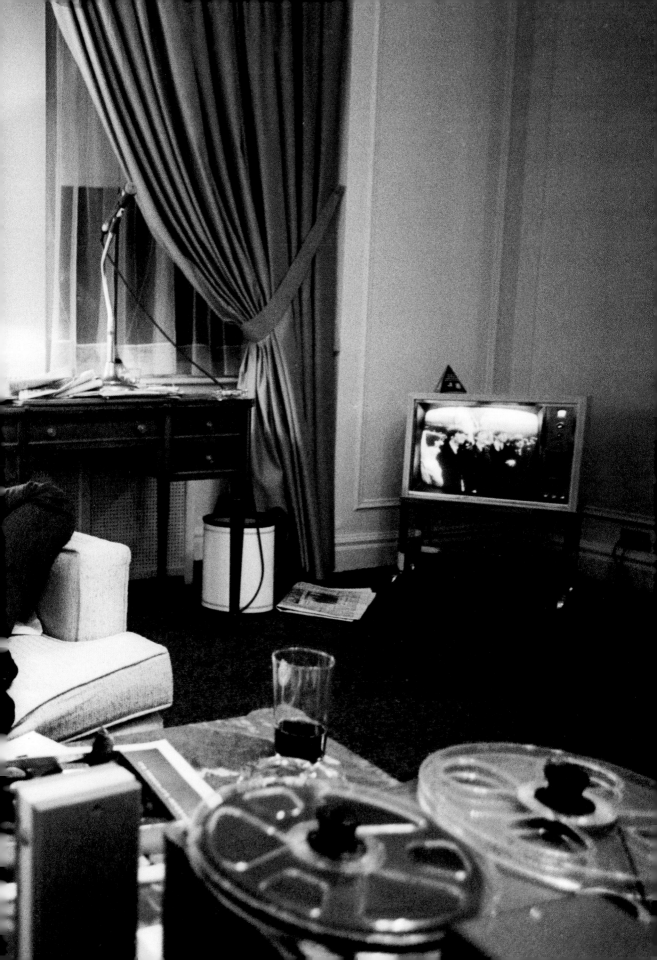

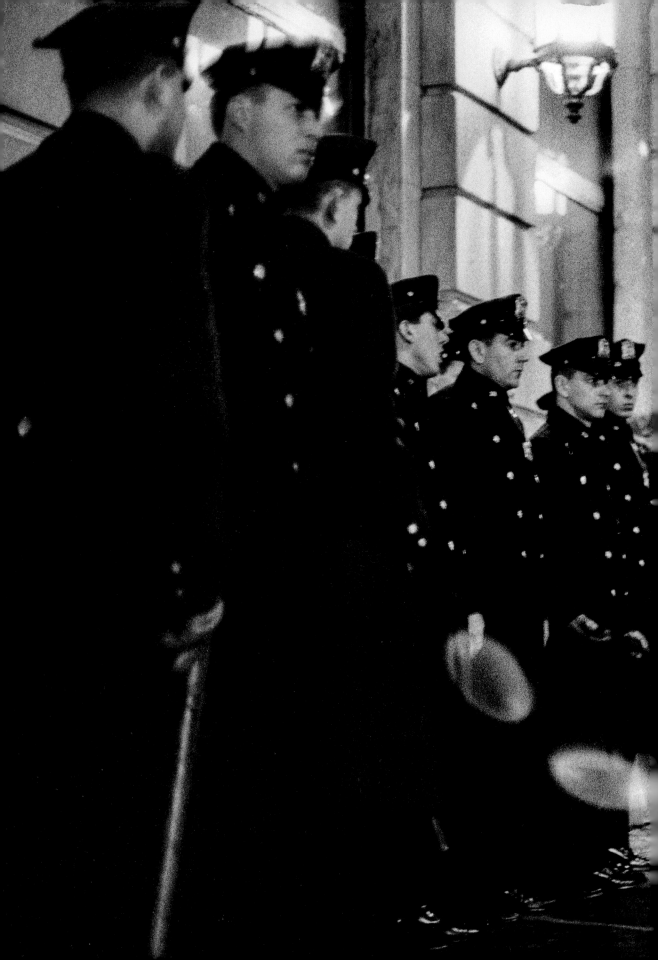

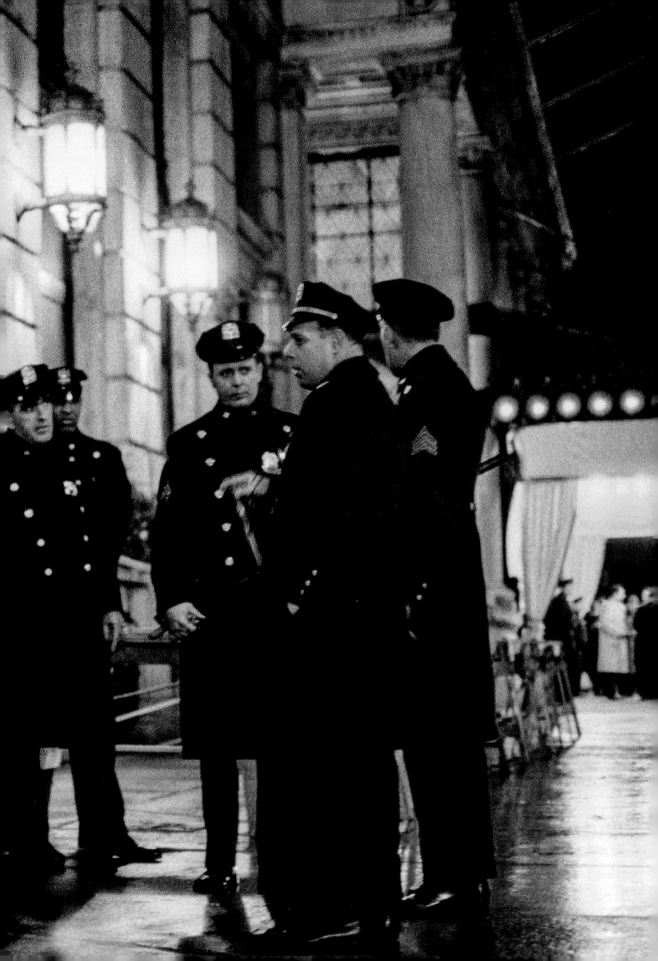

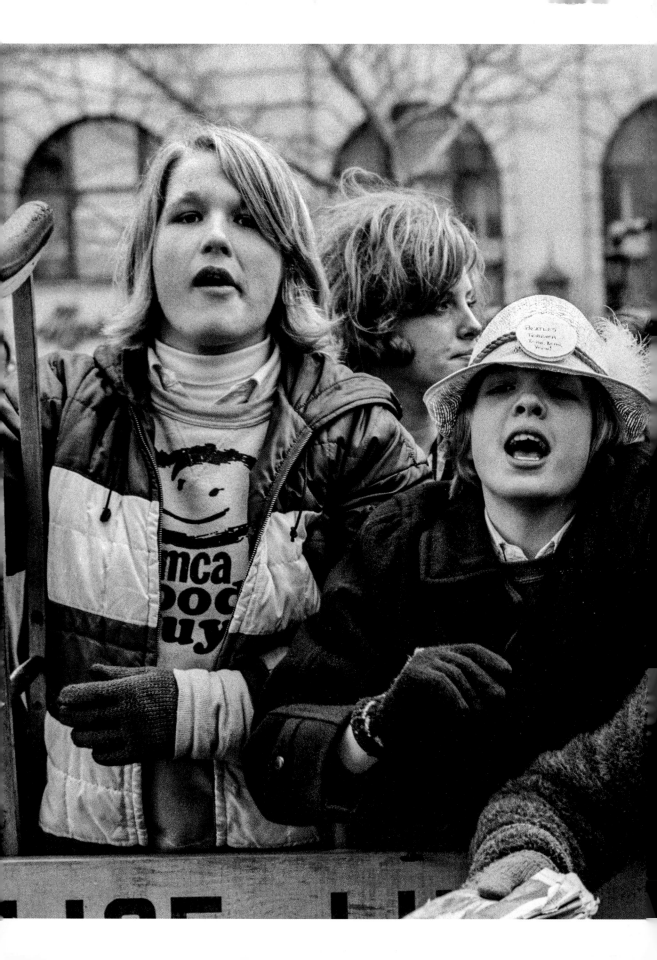

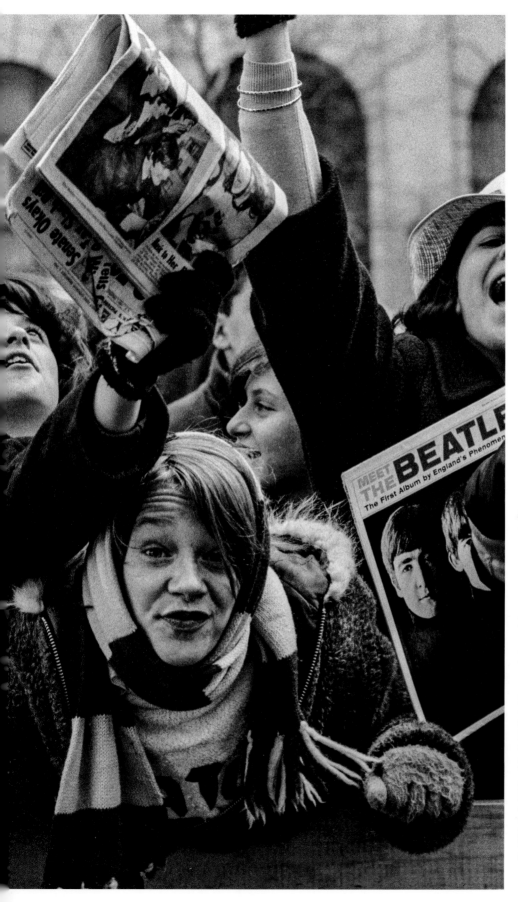

# DAY 2

A crowd of teenage girls outside the Plaza Hotel on Saturday morning, February 8, waiting for the Beatles to appear. They knew the band's schedule because local DJs kept announcing it over the radio.

Overleaf: John, Paul, and Ringo leave the Plaza Hotel at around noon for a photo op in Central Park. George was not feeling well so he stayed at the hotel. Paul looks back from the rear seat of the Chevrolet that belonged to one of the hotel security guards. They used that car to try to avoid being seen by the crowds but that failed when their police escort in front turned on its siren.

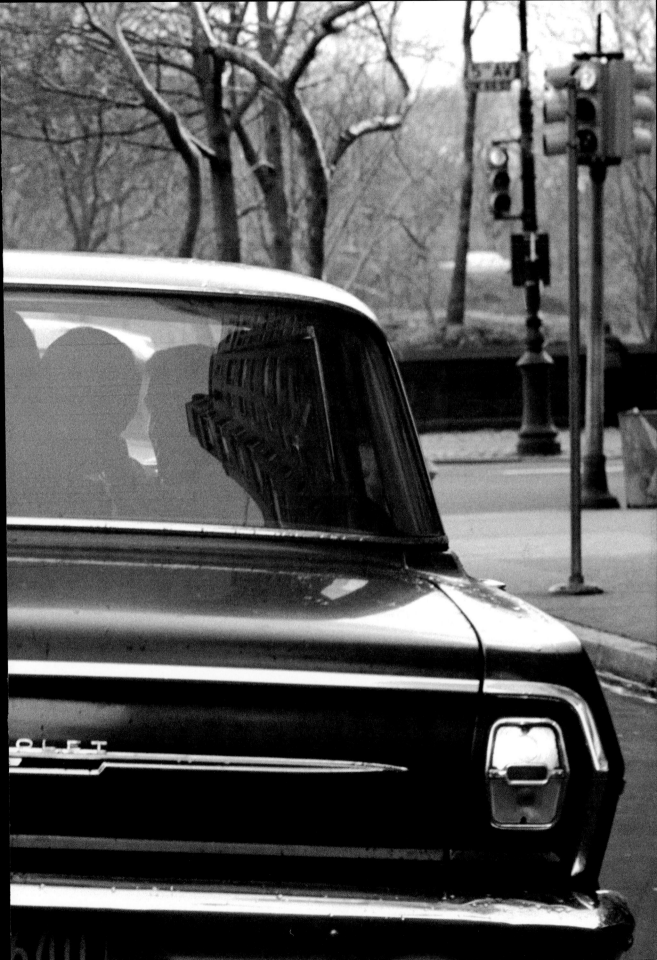

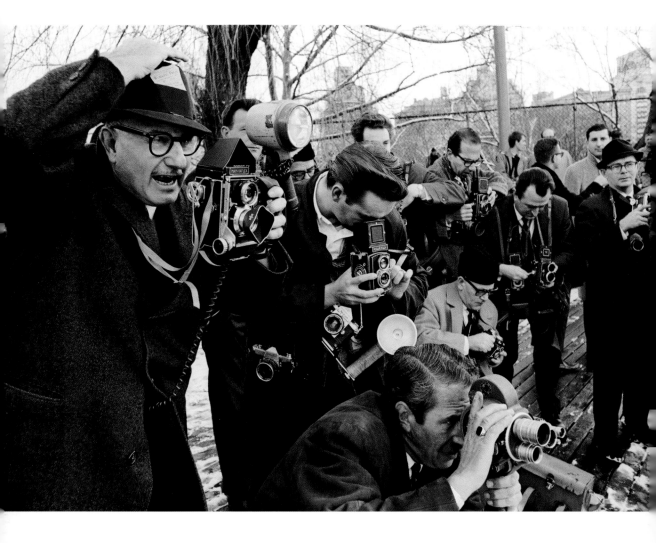

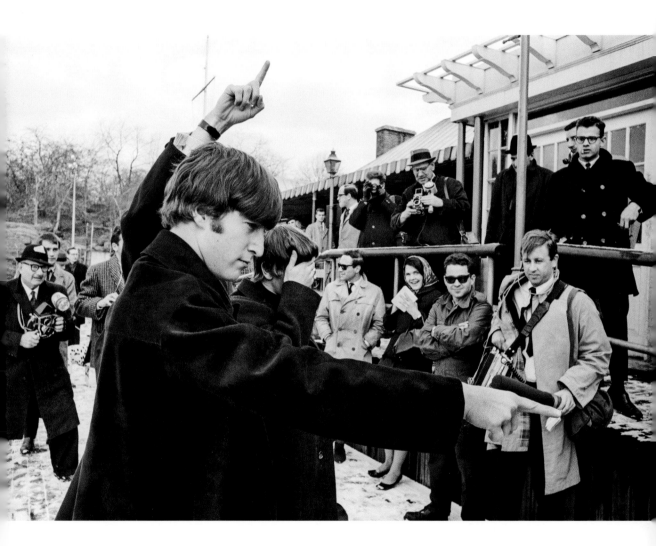

John, Paul, and Ringo surrounded by press
photographers at the Central Park Boathouse.
Filmmaker David Maysles stands in front
of the railing, holding a microphone.

Overleaf: Photographer Eddie Adams taking
a picture of John, Paul, and Ringo.

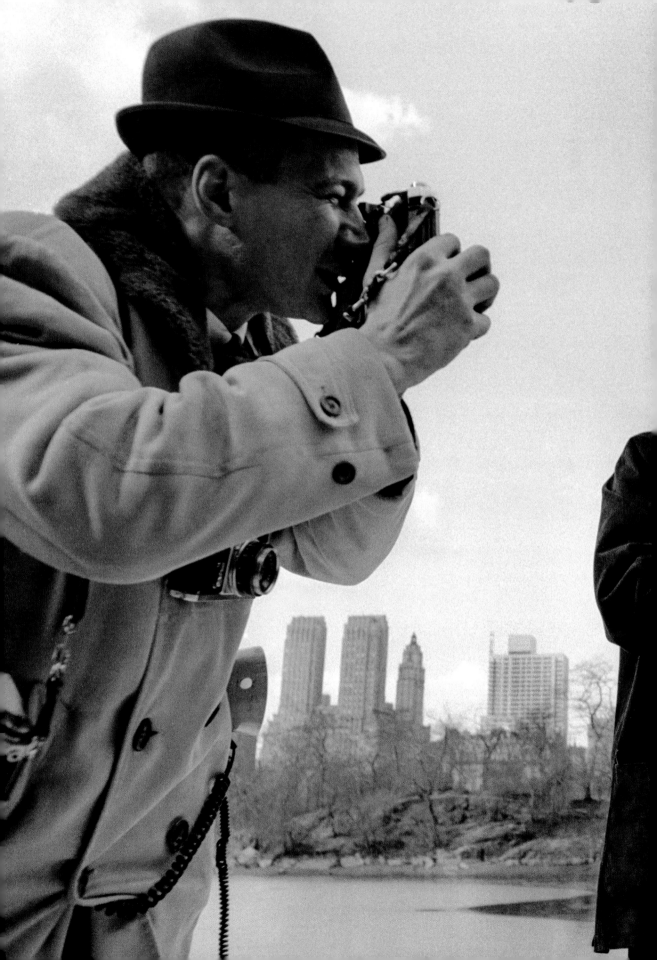

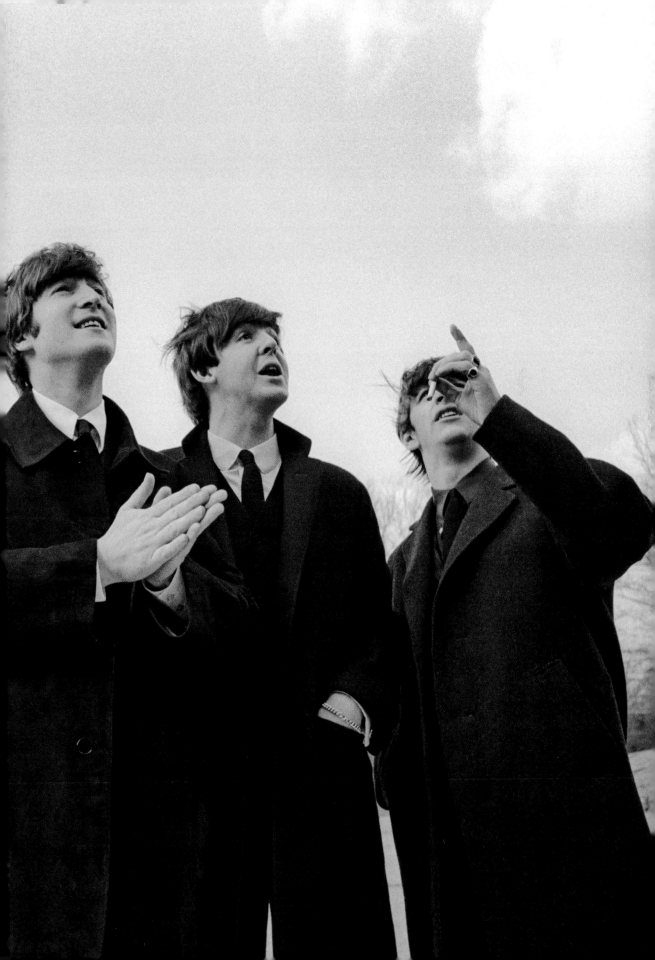

John holds a young fan during the
photo op in Central Park.

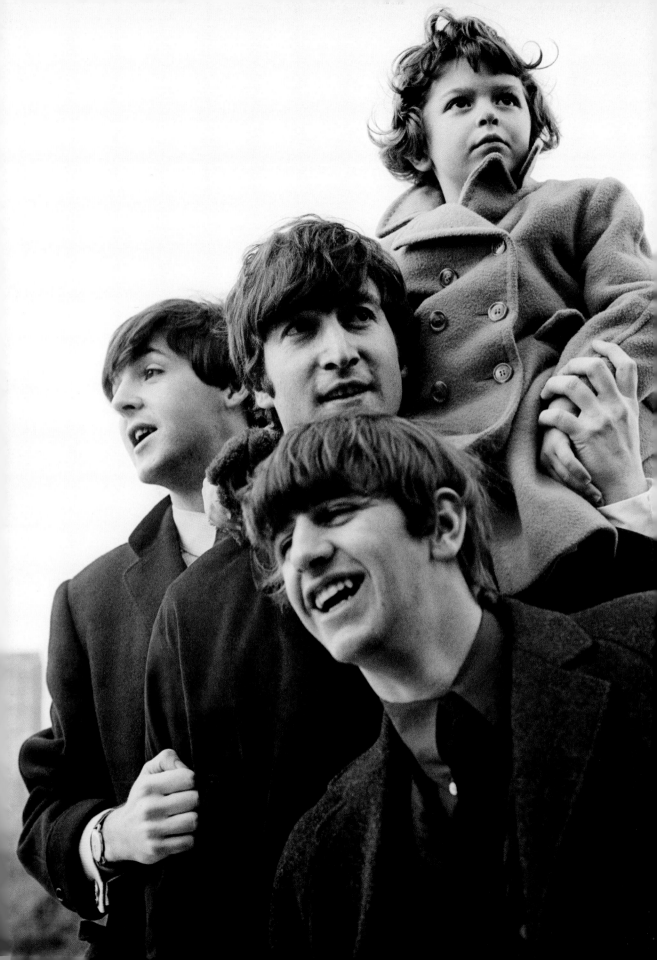

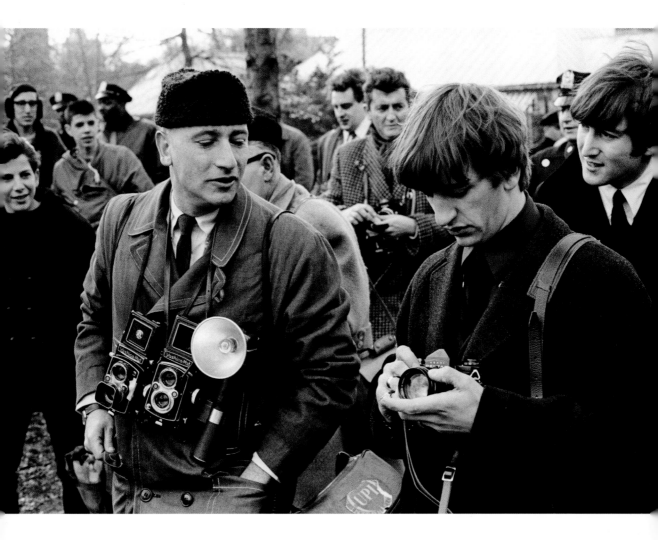

Associated Press photographer Joel Landau discusses photography with Ringo as John listens. All four of the Beatles had camera equipment with them on their trip to the United States.

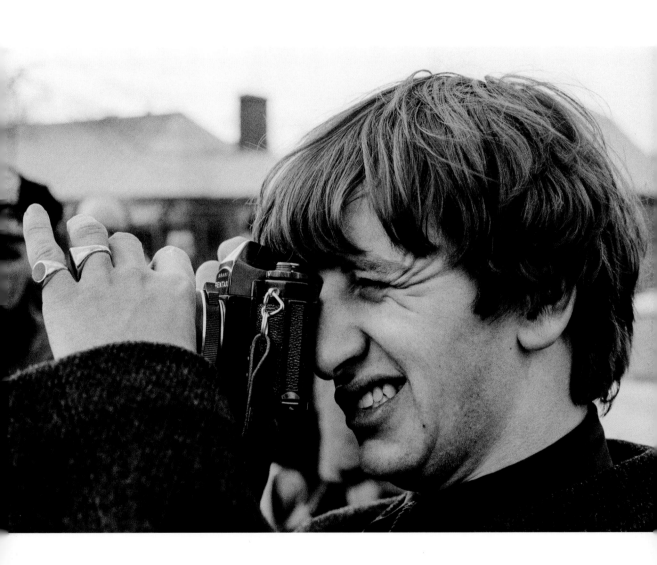

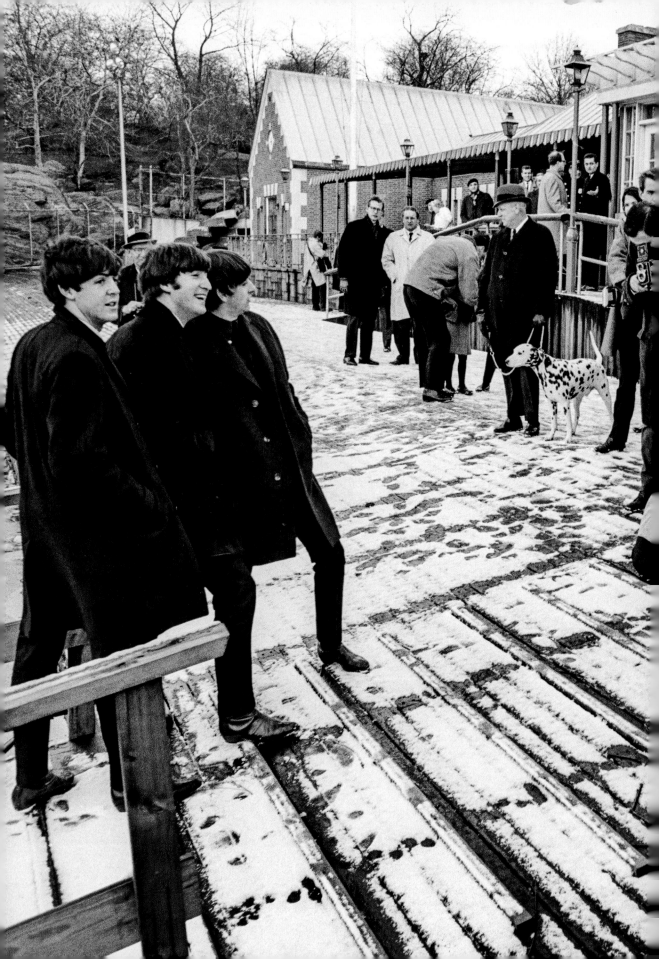

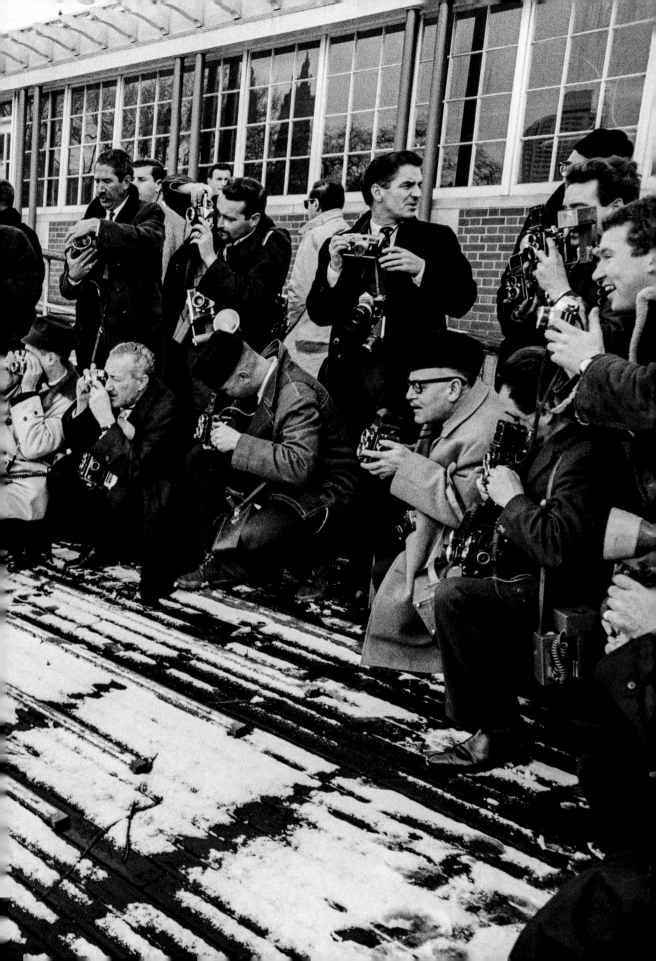

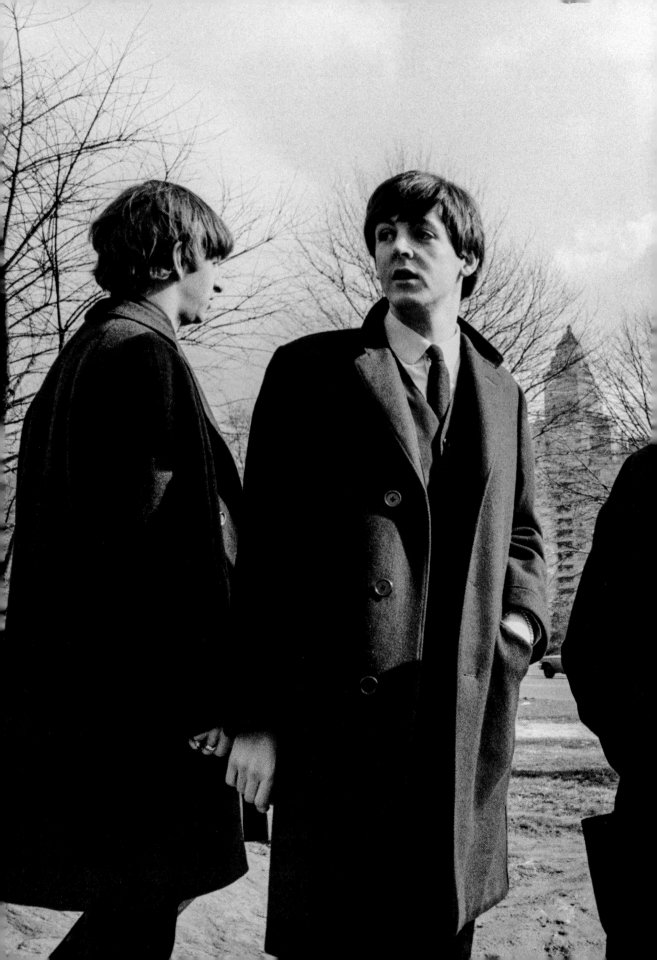

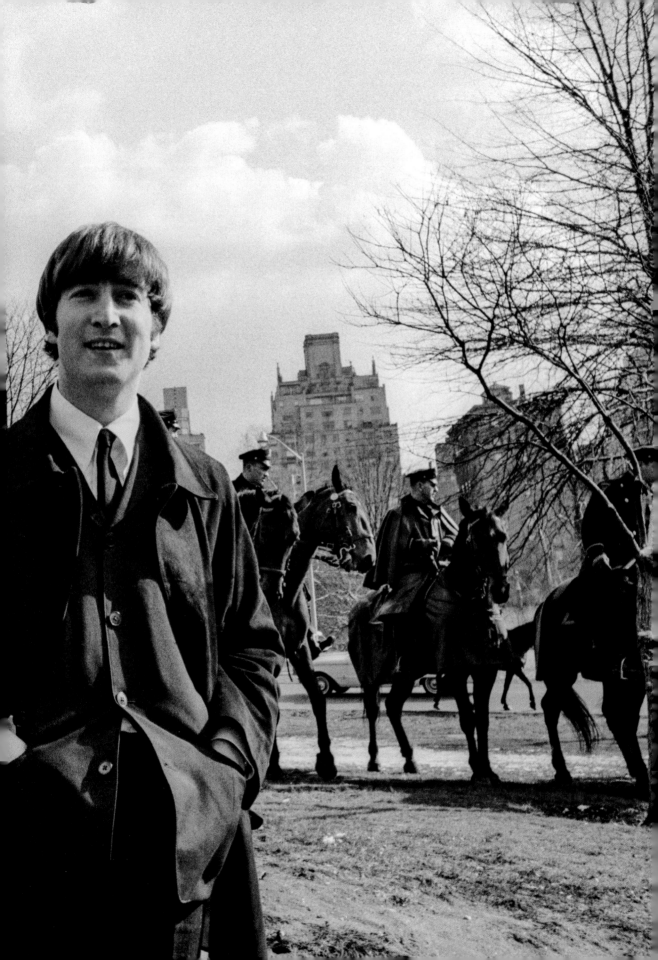

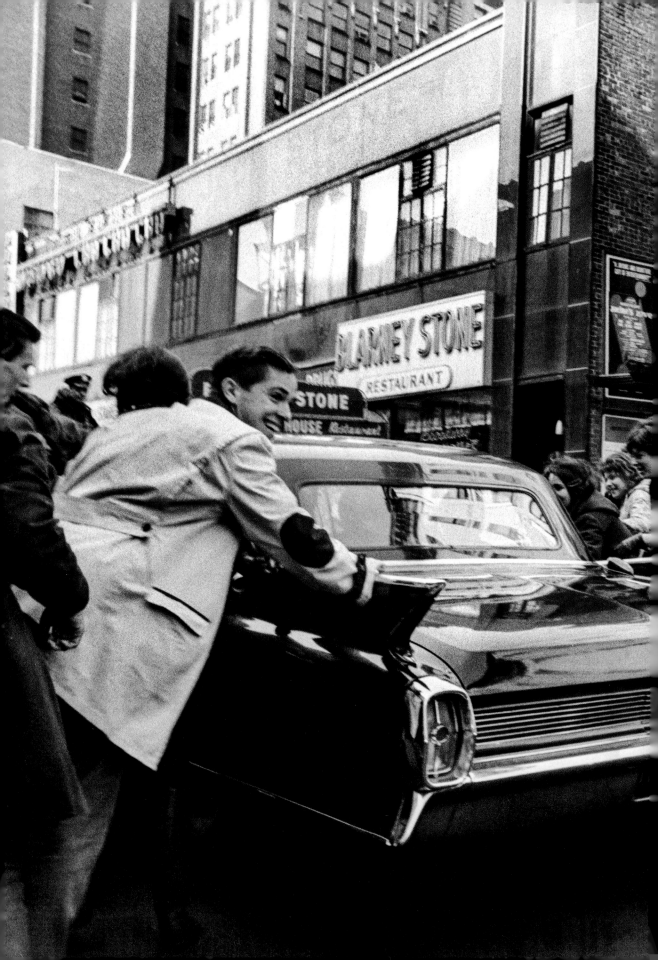

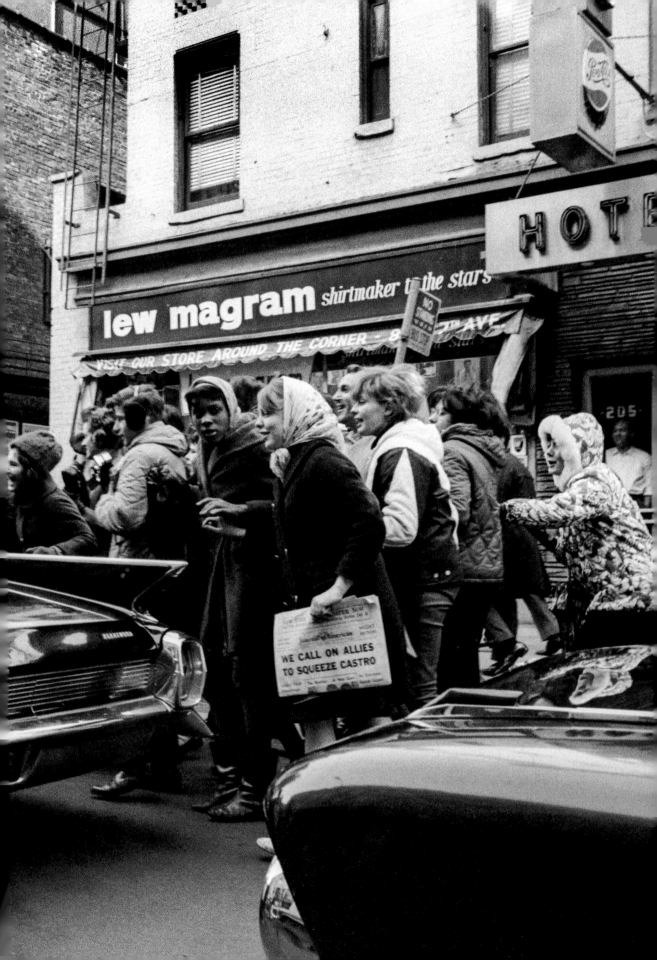

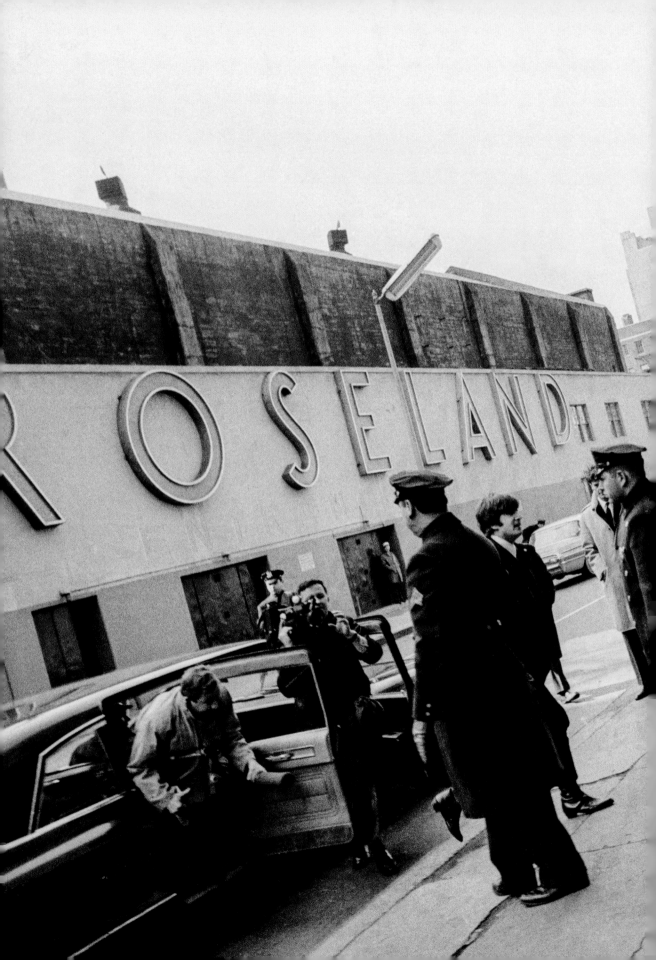

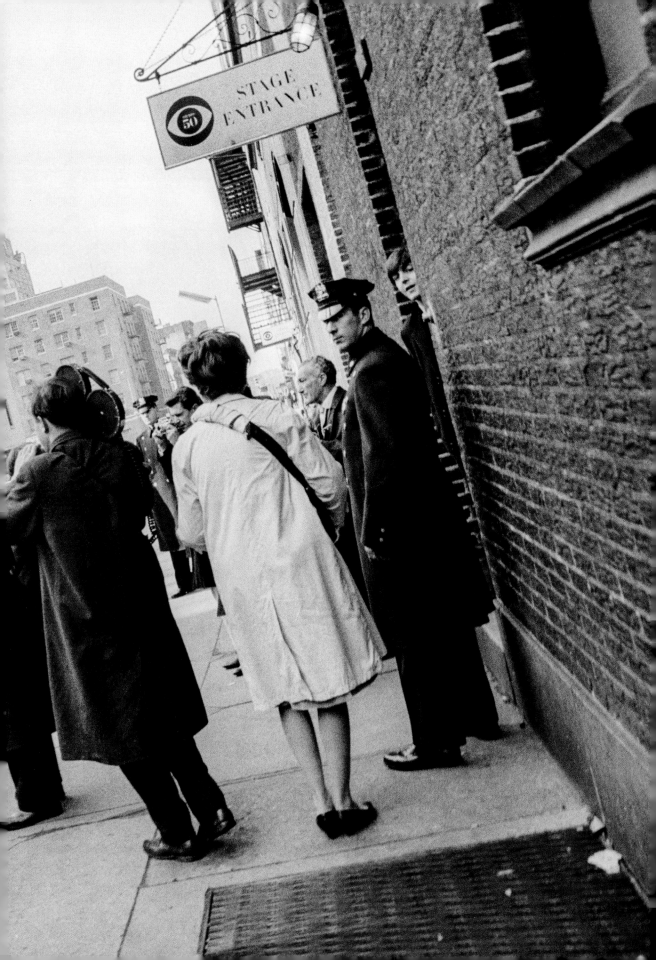

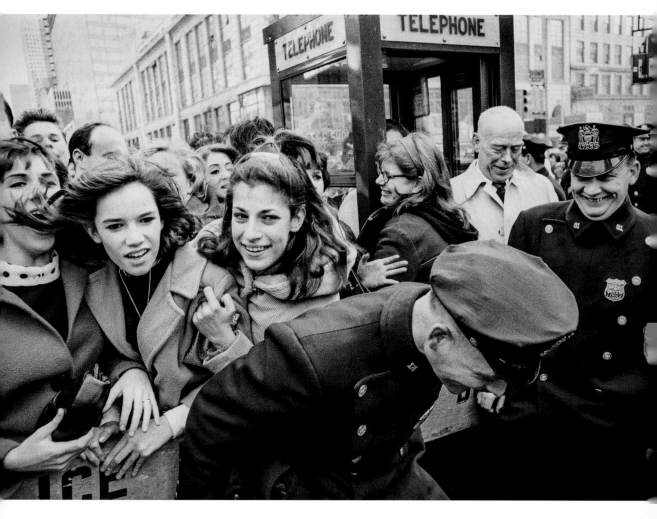

Preceding pages: John, Paul, and Ringo along with filmmakers Albert and David Maysles leave Central Park by limousine to arrive at the stage entrance to the theater hosting *The Ed Sullivan Show*, CBS-TV Studio 50, at approximately 1:30 p.m. Paul looks out from the doorway as John and Ringo (not visible) head inside. George was still resting at the Plaza Hotel and would not arrive until later in the afternoon.

Above: Police restrain the crowd of fans outside the theater at 1697 Broadway.

Overleaf: The Beatles rehearse without George. Neil Aspinall, their road manager, was a stand-in for George although he never played the guitar he was holding. The background set shown here was not used for the actual performances.

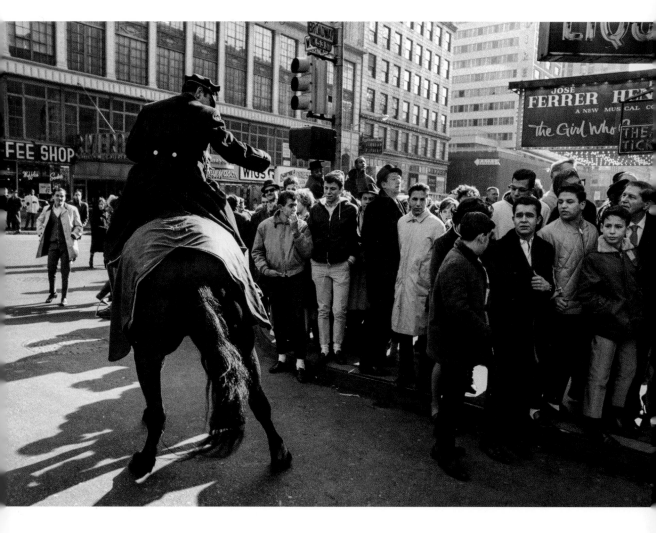

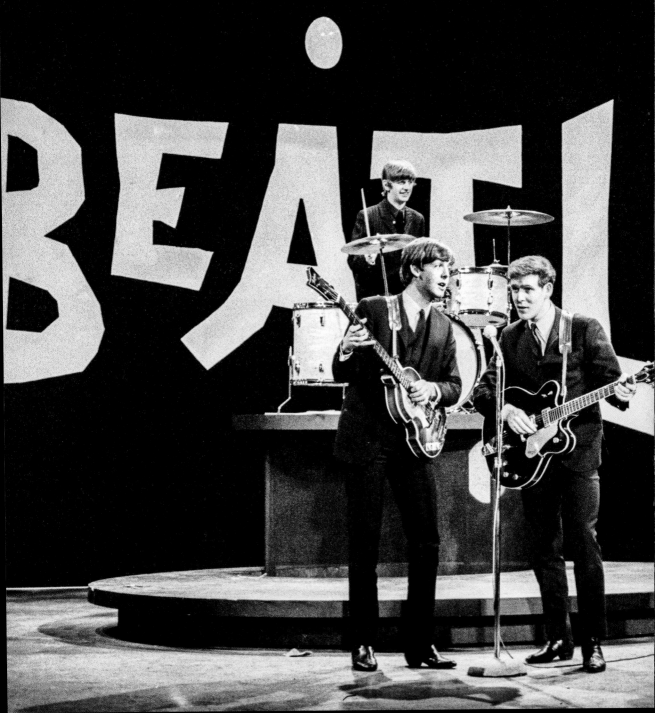

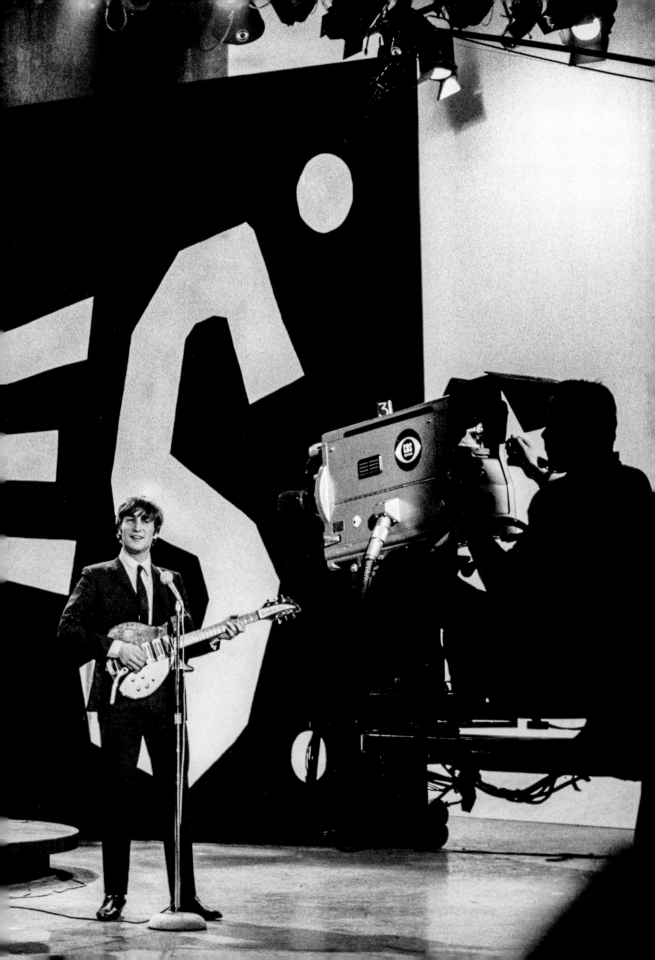

Paul, John, and Ringo rehearse with
Neil Aspinall standing in for George on
the set that would be used for the live
performance on Sunday night.

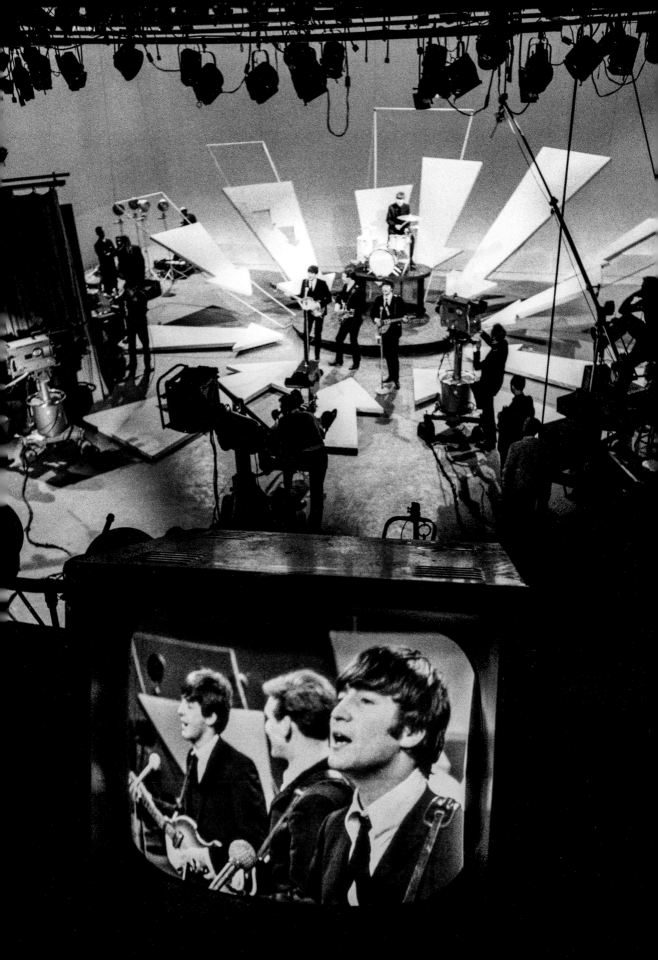

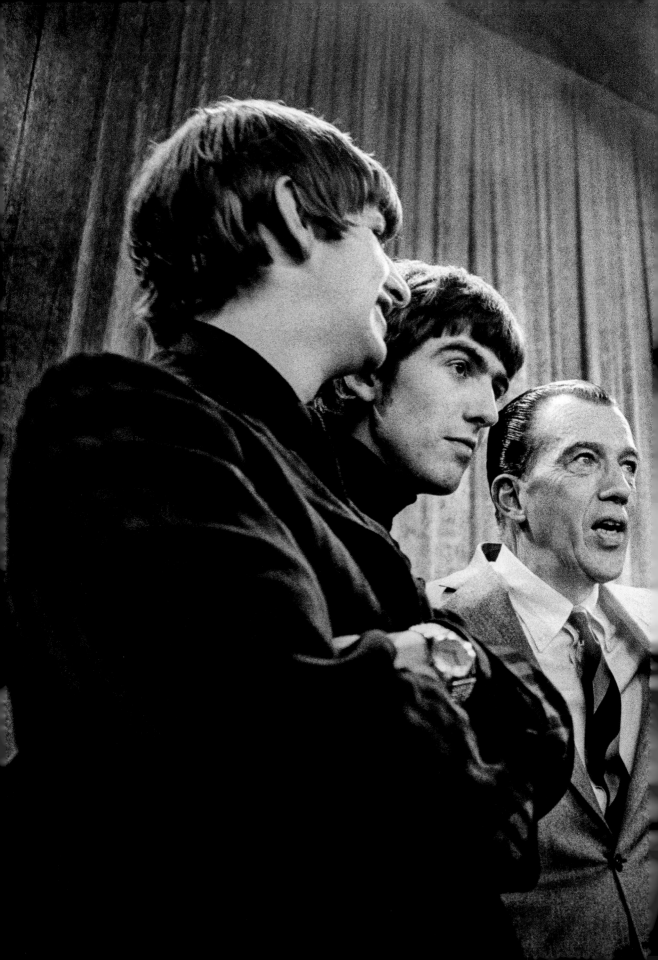

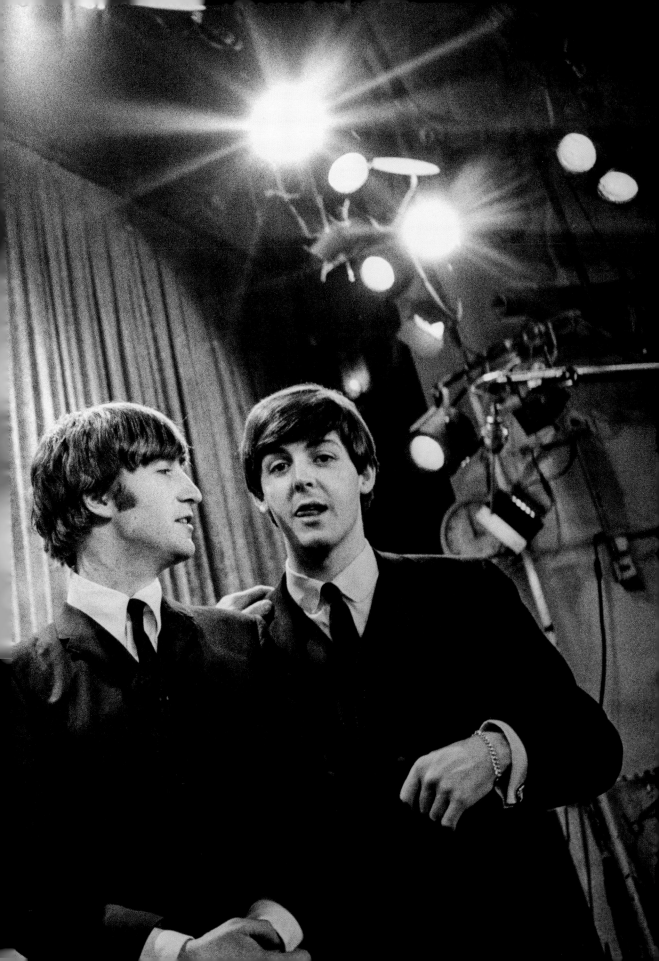

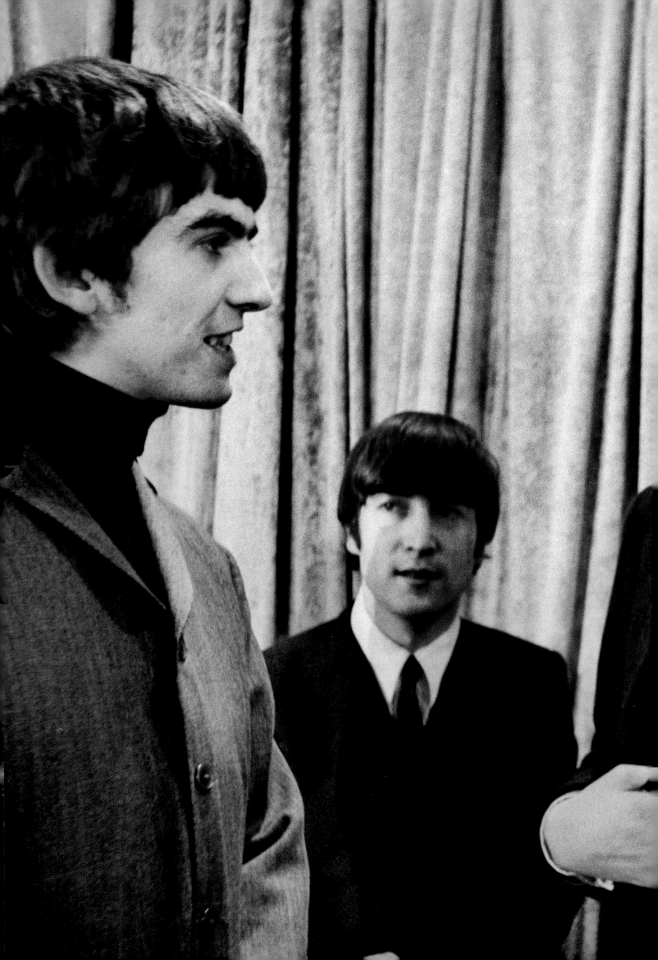

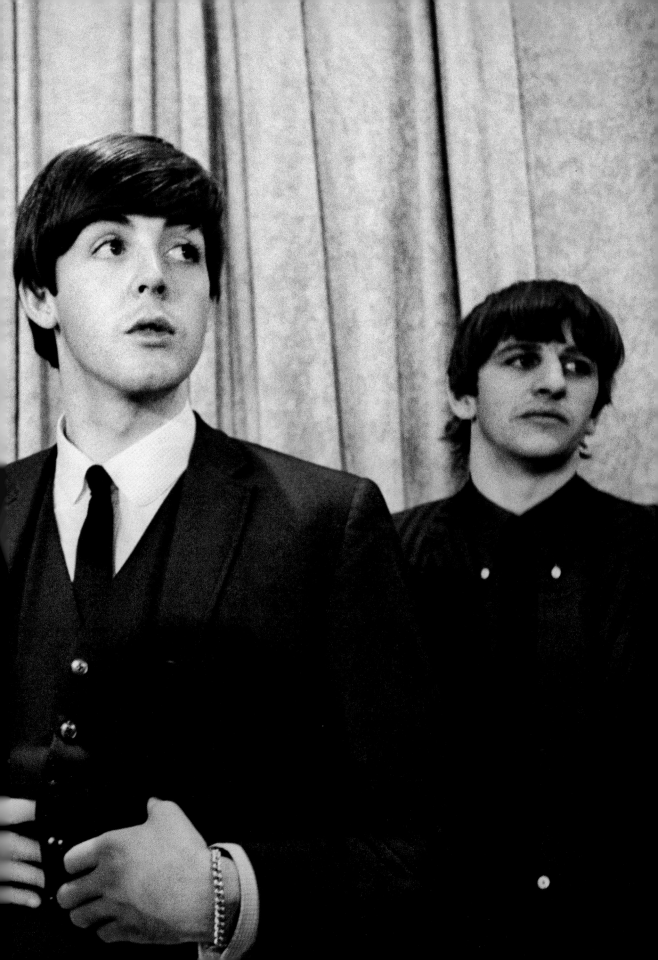

Preceding pages: George joins the rest of
the Beatles at CBS-TV Studio 50 and the
band meets with Ed Sullivan.

Opposite: Nancy Cronkite (left) and Kathy
Cronkite (right), daughters of Walter
Cronkite, with Paul and Ringo.

Following pages: *The Ed Sullivan Show*
production secretary Kathie Kuehl writes
down the words to the song "She Loves
You" as Paul sings them; Ed Sullivan tries
out Paul's left-handed Höfner bass guitar.
Brian Epstein, the Beatles' manager,
stands behind Sullivan.

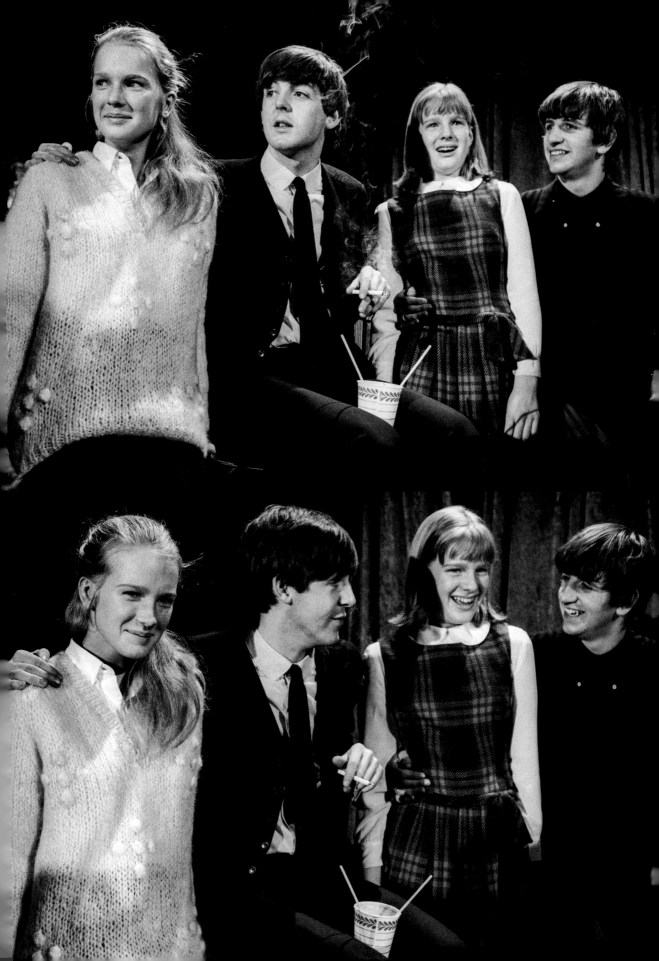

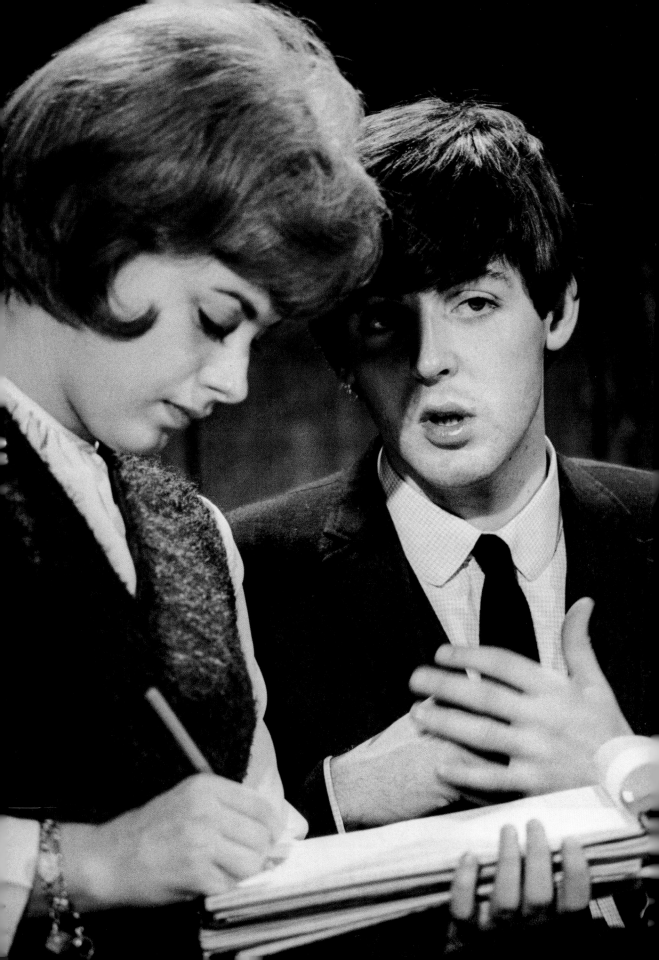

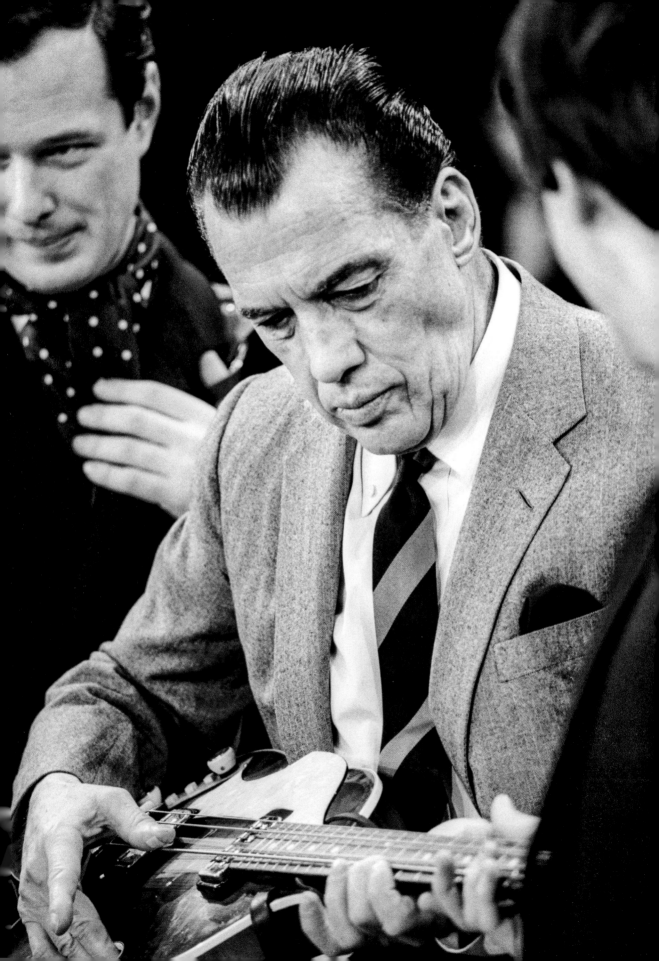

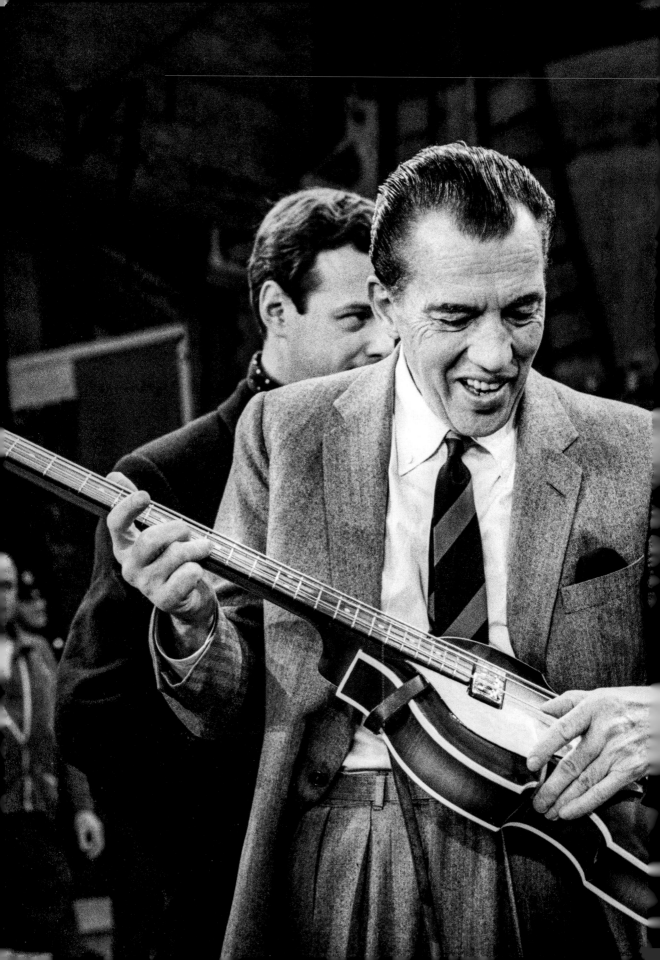

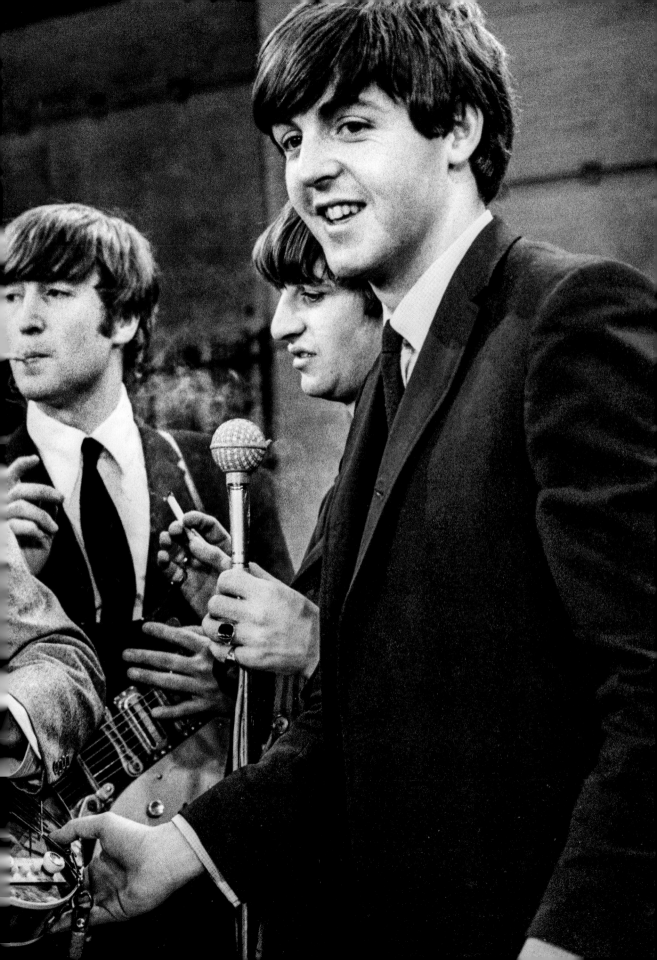

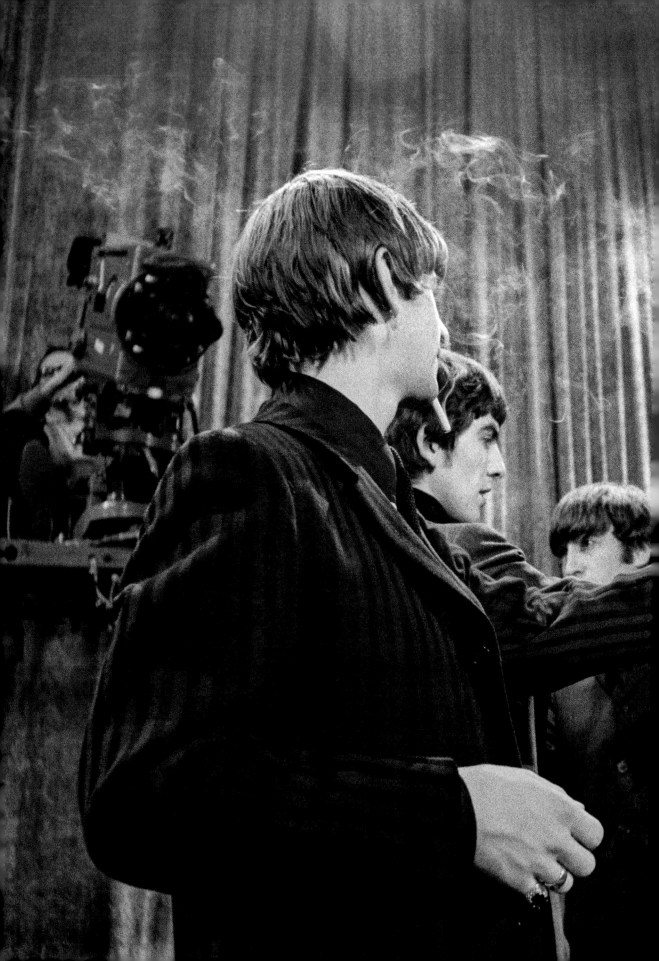

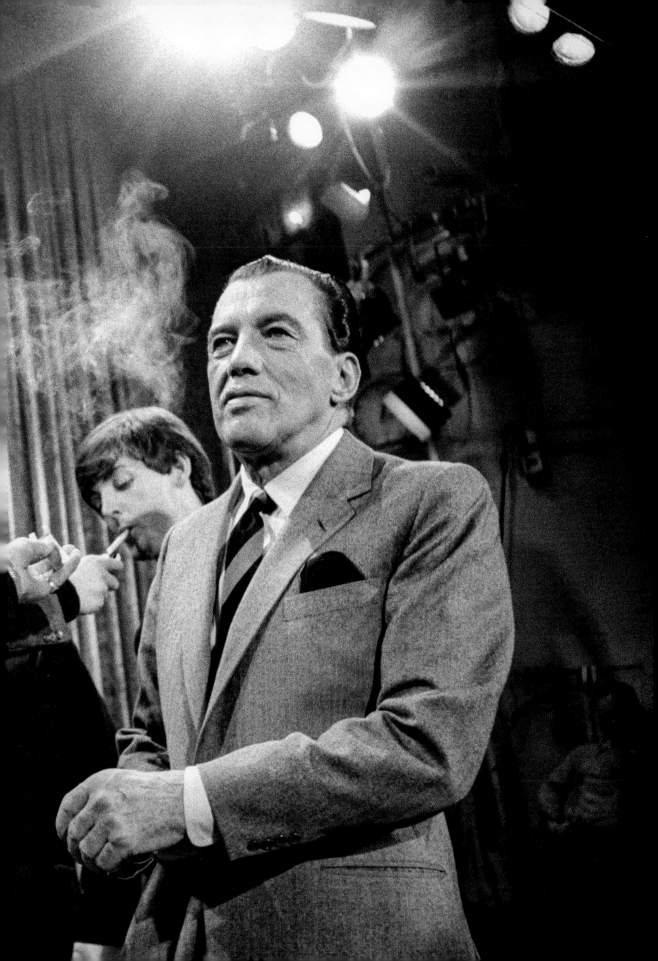

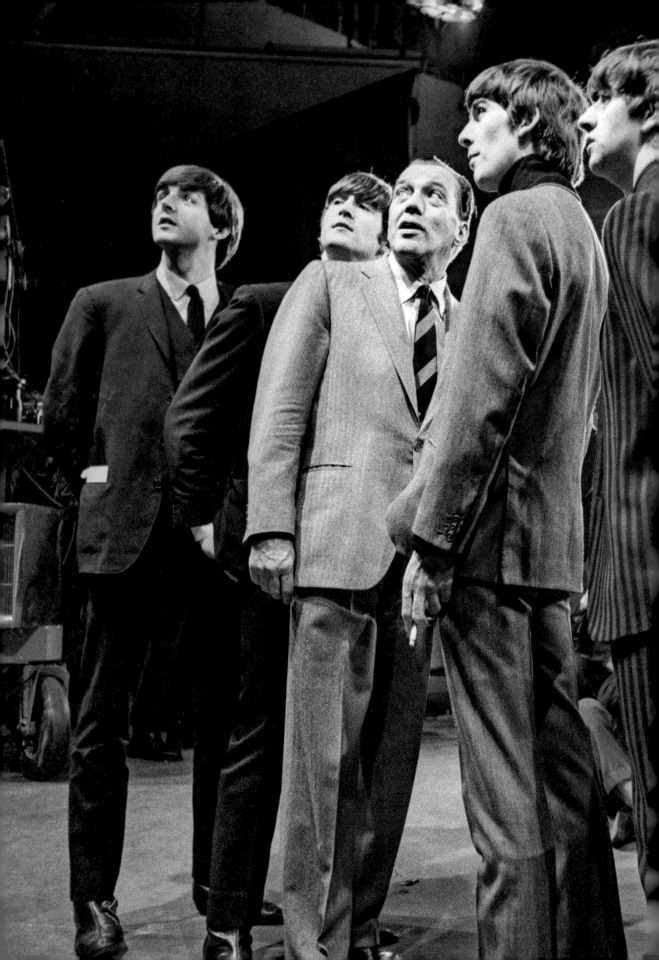

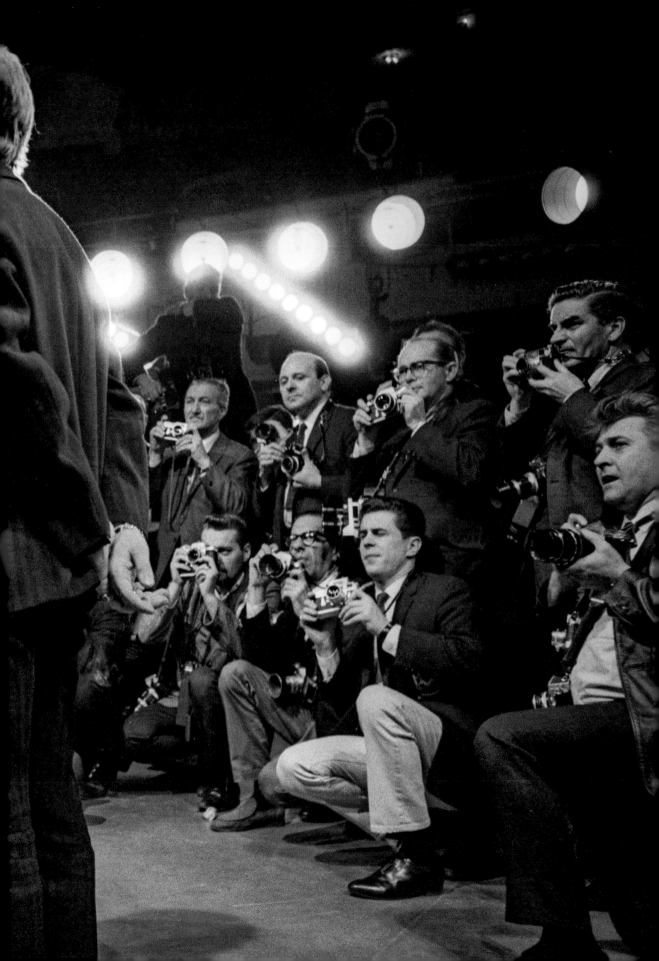

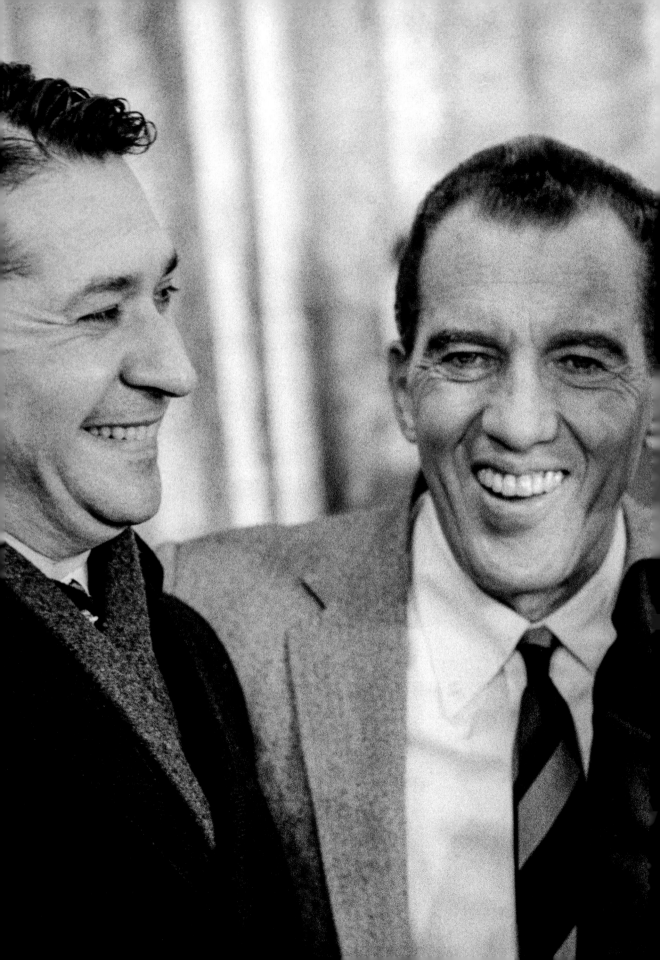

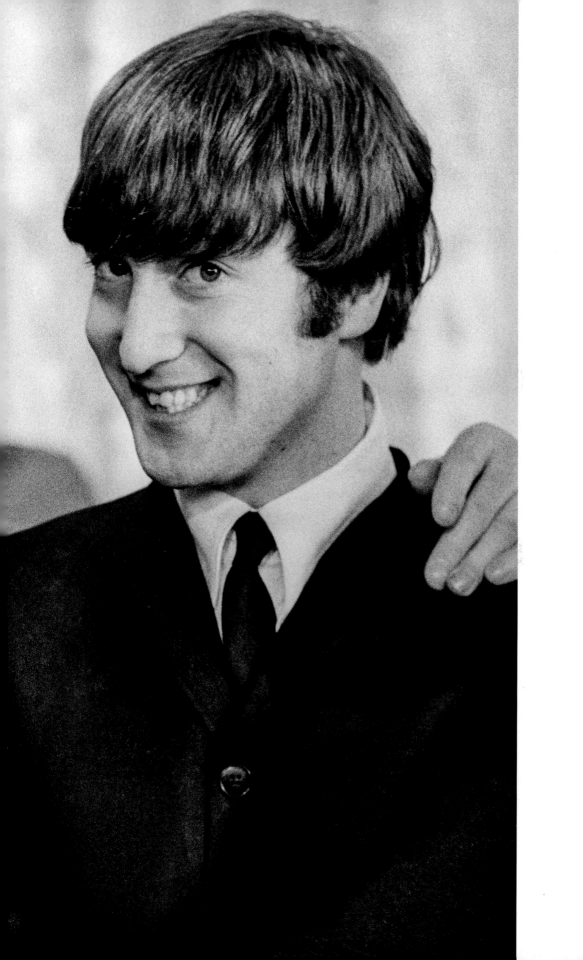

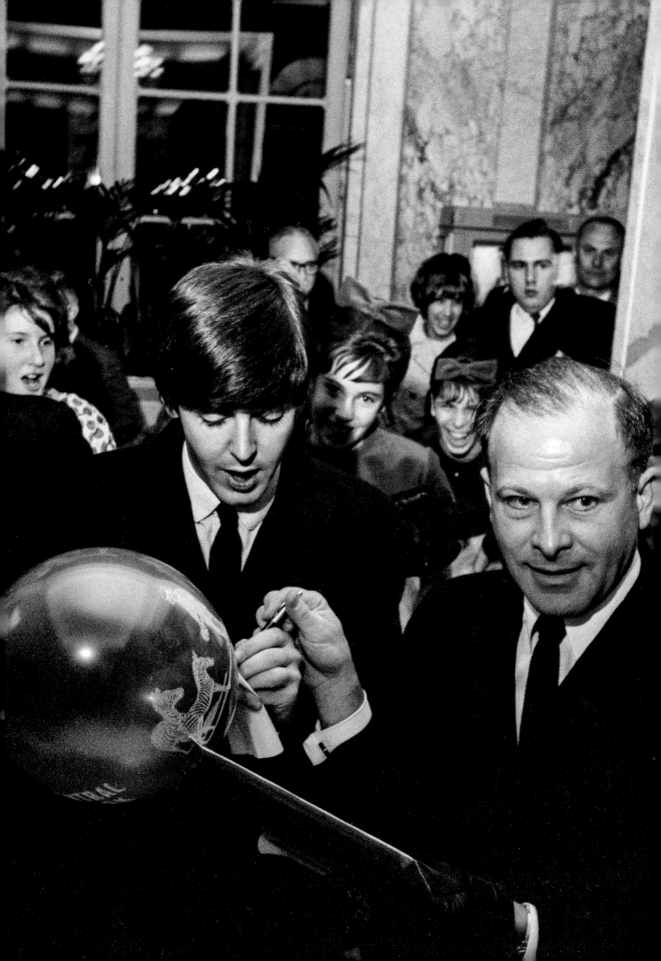

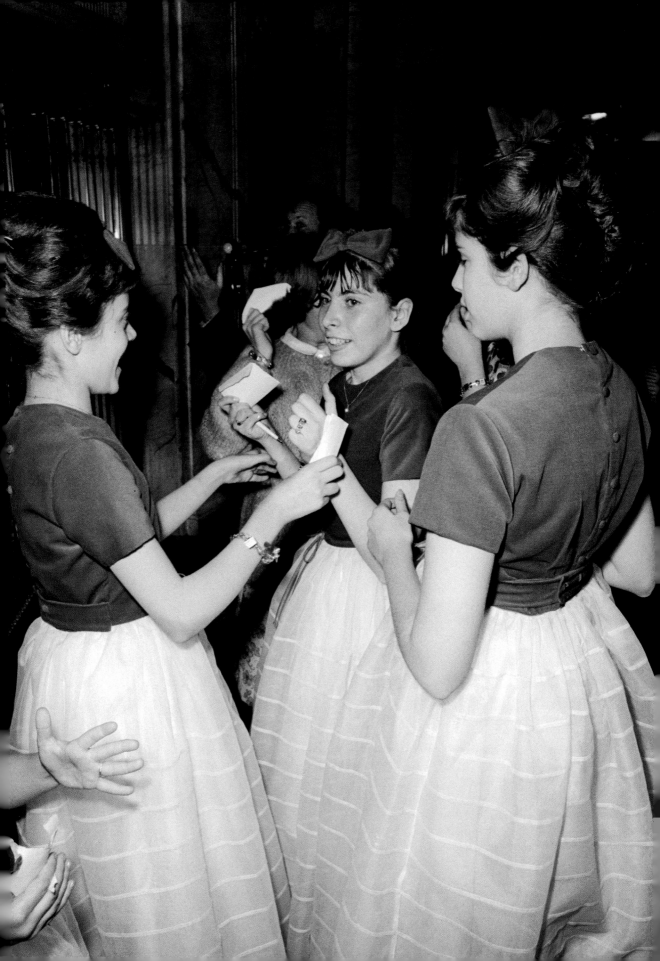

Preceding pages: Paul signs
autographs in the Plaza Hotel lobby
in the evening; fans holding slips of
paper just autographed by Paul.

Opposite: A group of fans try to gain
entry to the Plaza Hotel.

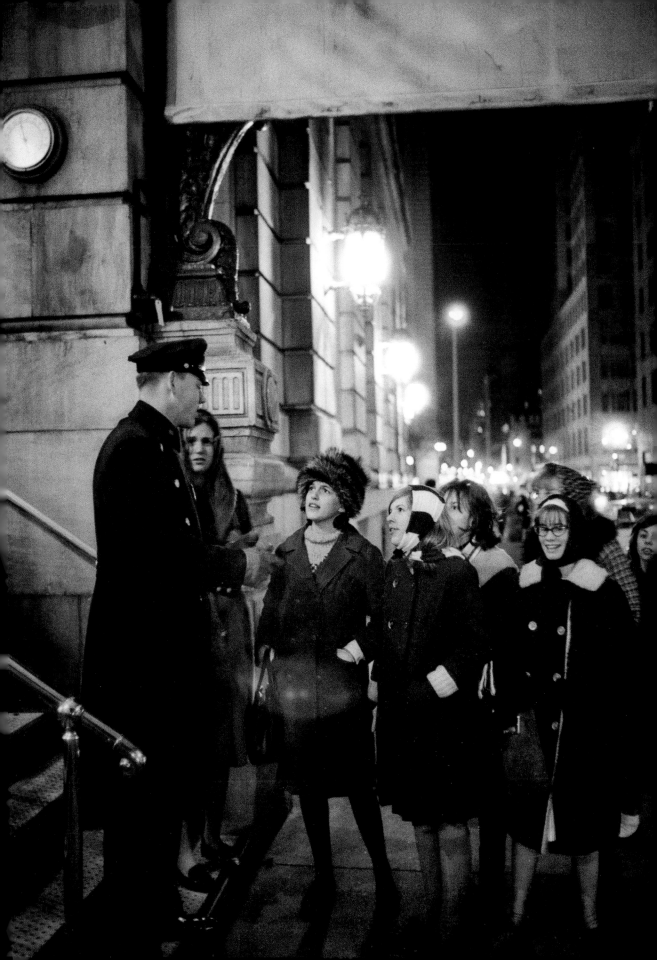

# DAY 3

Fans run toward the stage-door entrance of CBS-TV Studio 50, trying to catch the Beatles before they arrive for morning rehearsals of *The Ed Sullivan Show* on Sunday, February 9. The Beatles, however, had already entered the building.

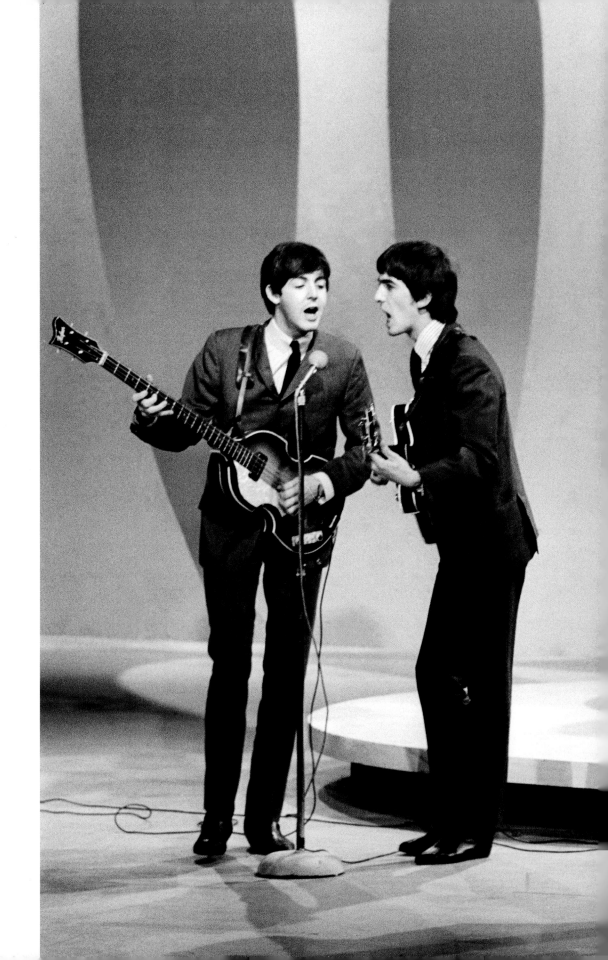

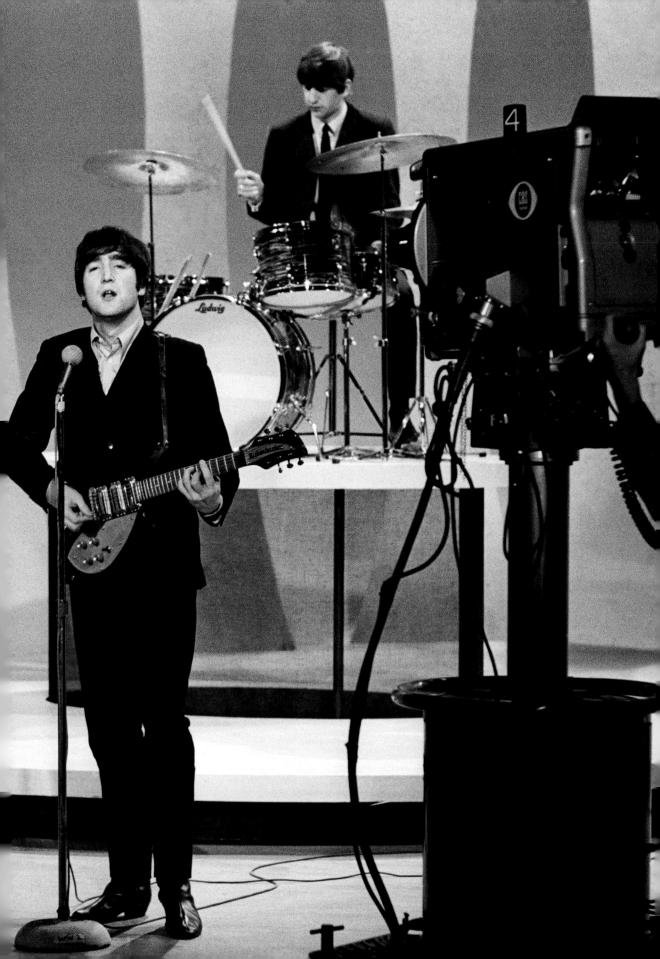

Preceding pages: The Beatles at the Sunday morning dress rehearsal. This set would later be used for the taped show that aired on February 23, 1964.

Opposite: John takes a break during the morning dress rehearsal.

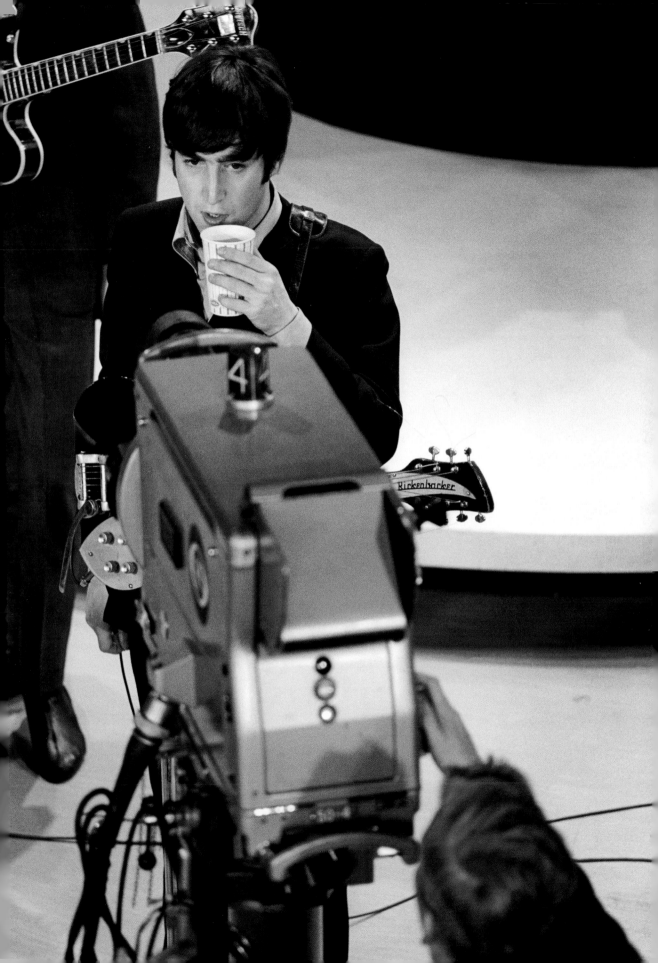

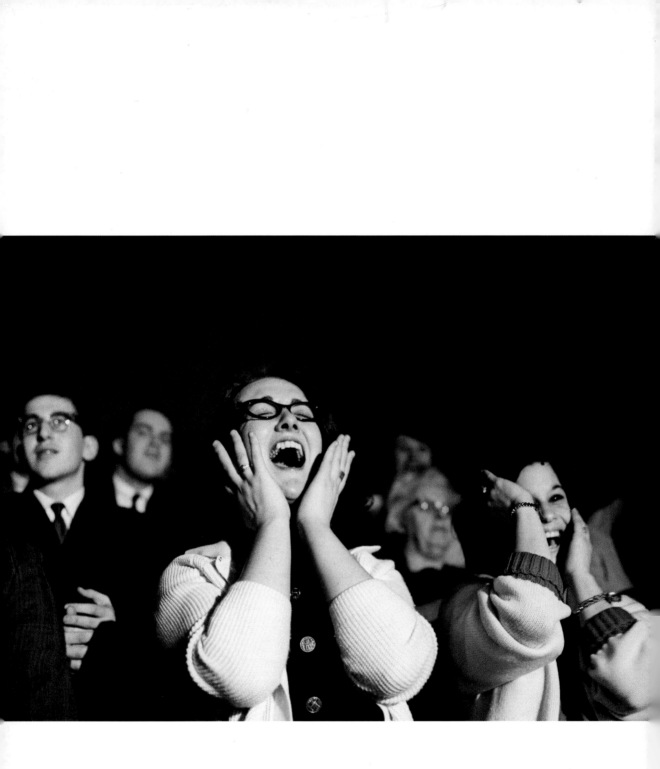

The audience reacts to the Beatles' *Ed Sullivan Show* performance.

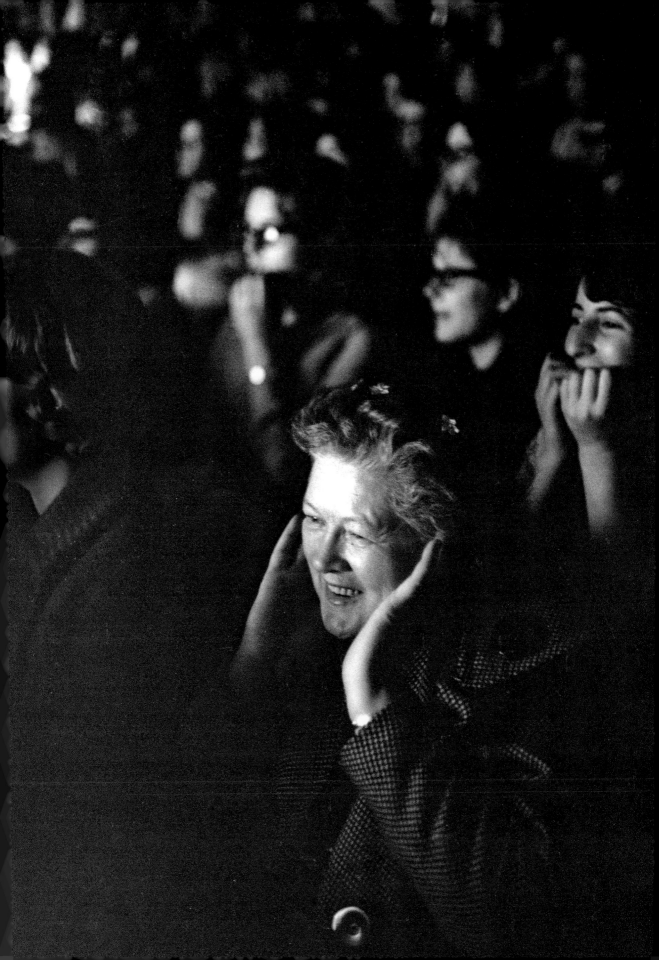

The Beatles, with Cynthia Lennon, leave the
Plaza Hotel for dinner at the Playboy Club,
after *The Ed Sullivan Show* performance.

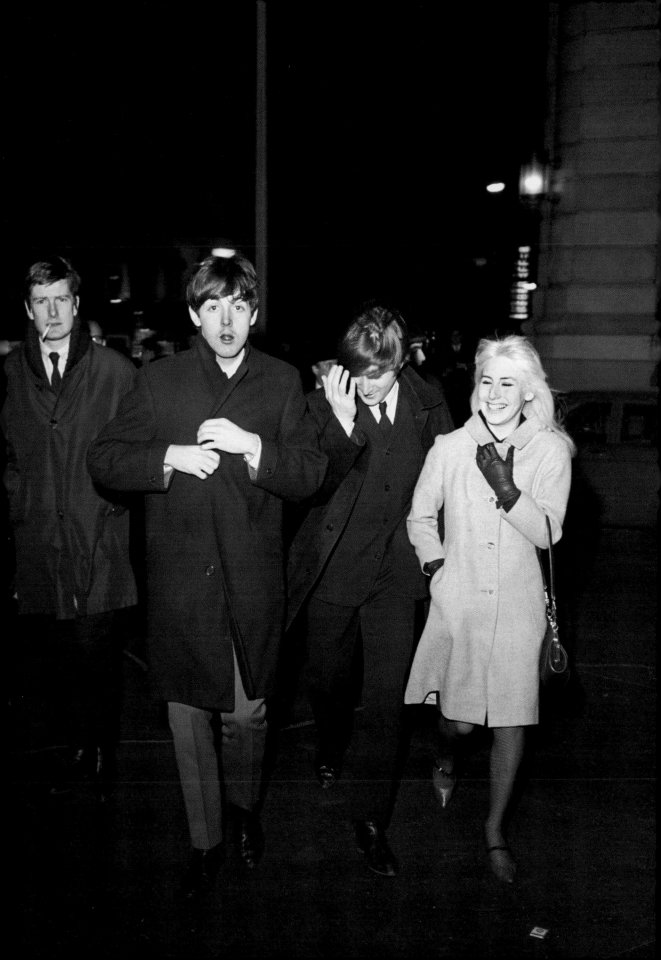

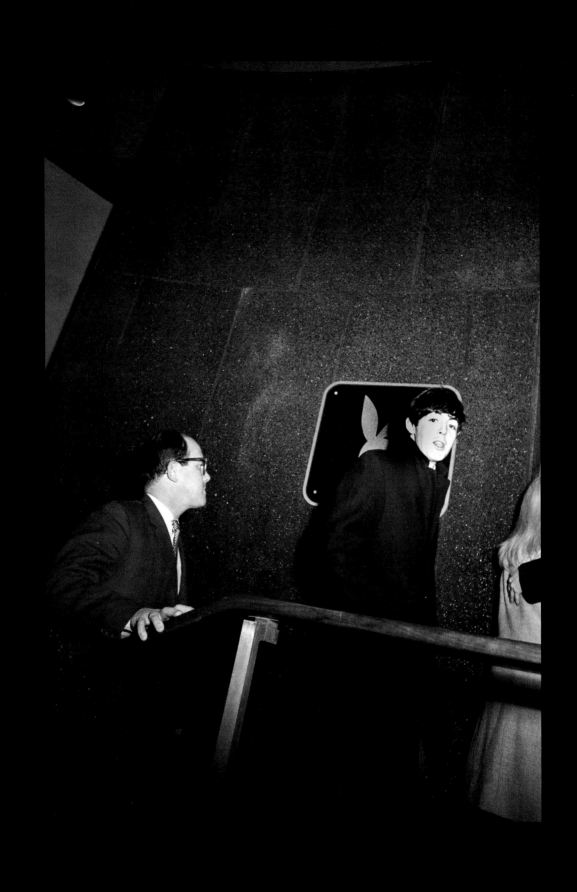

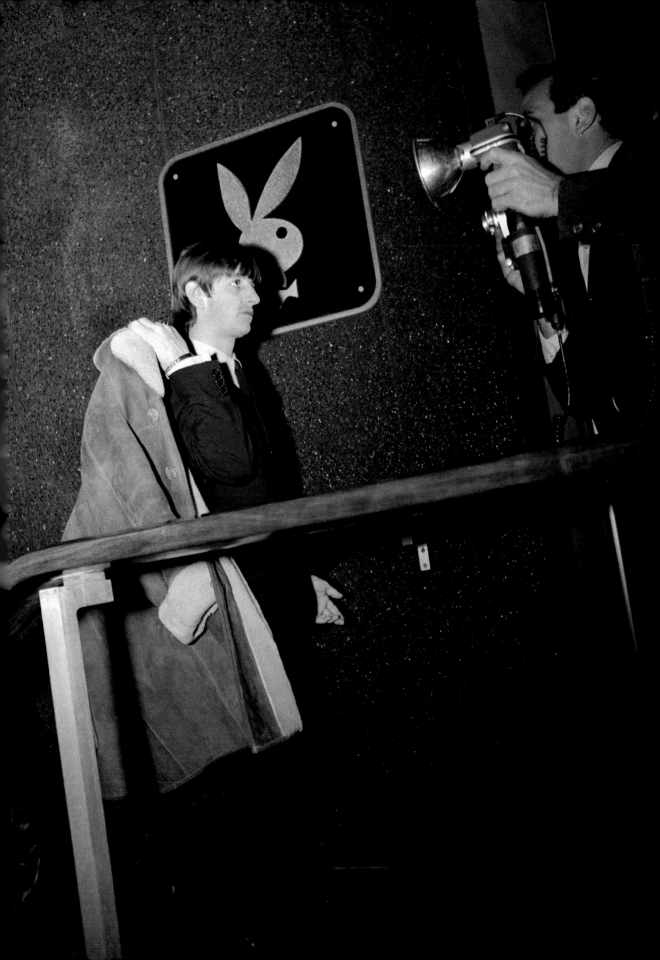

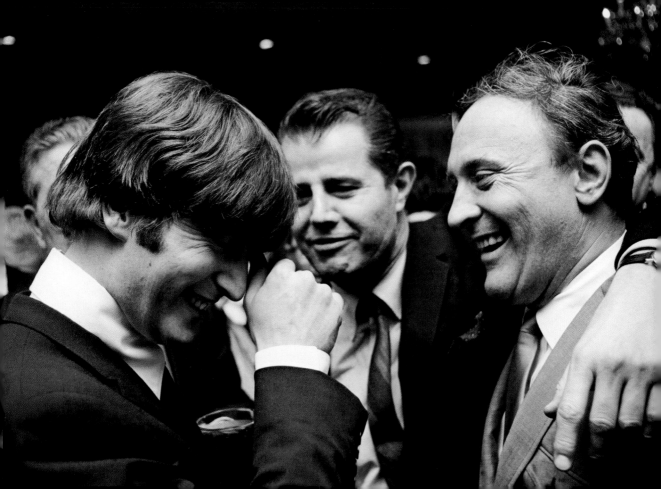

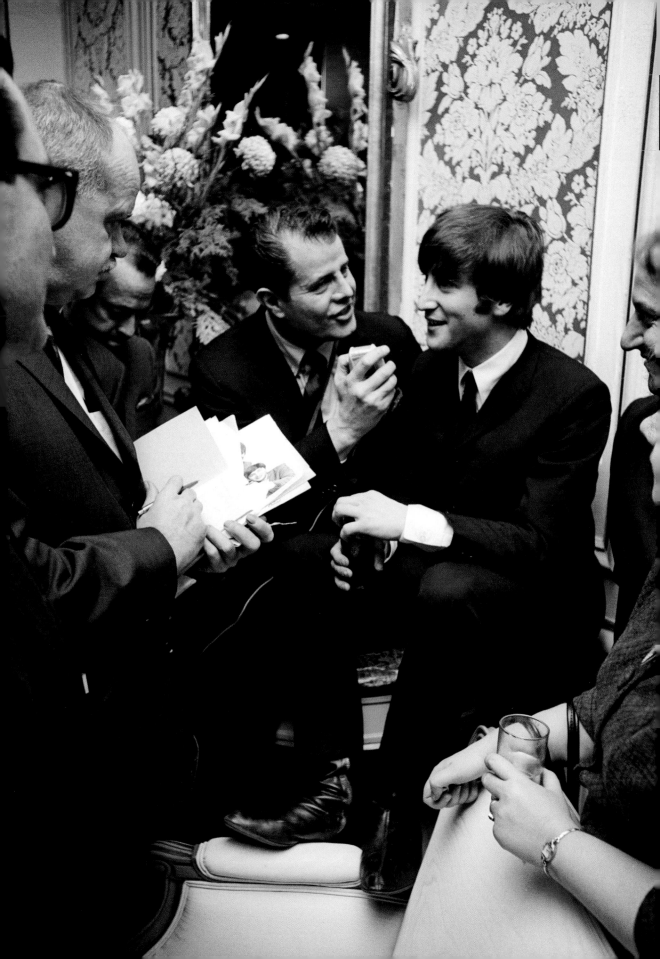

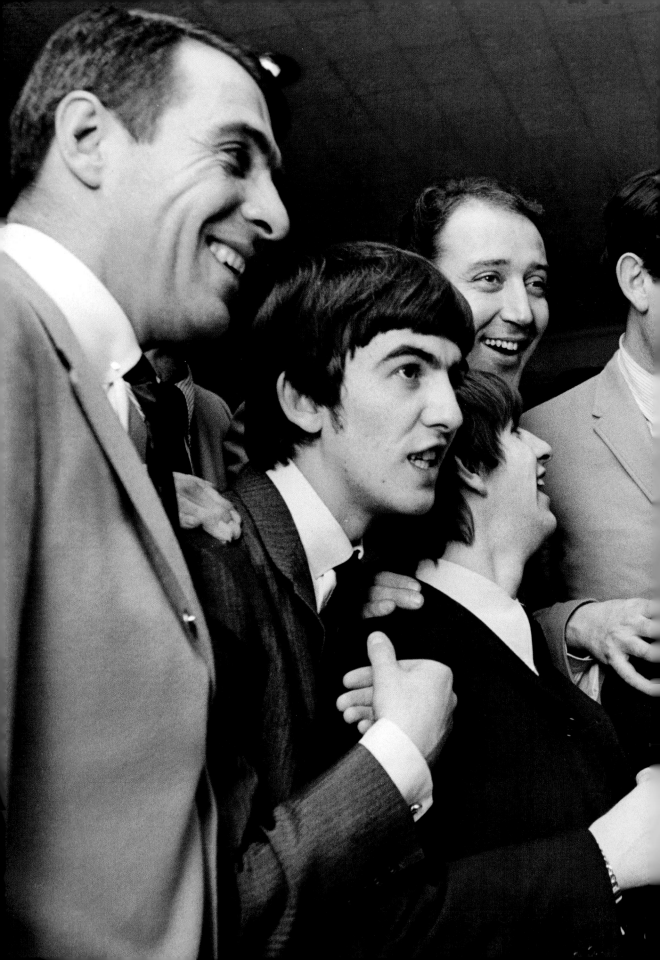

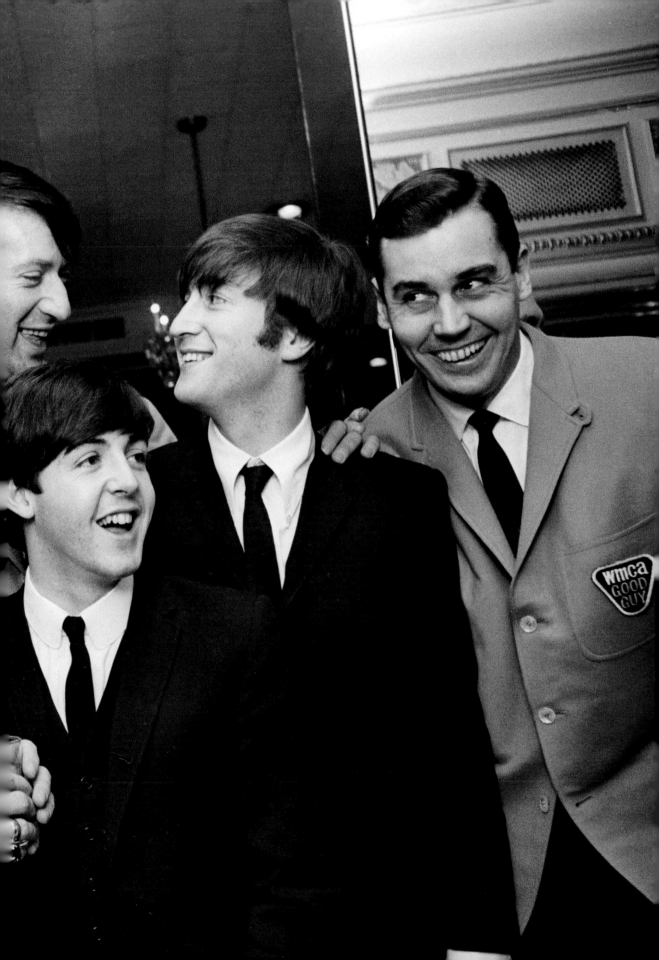

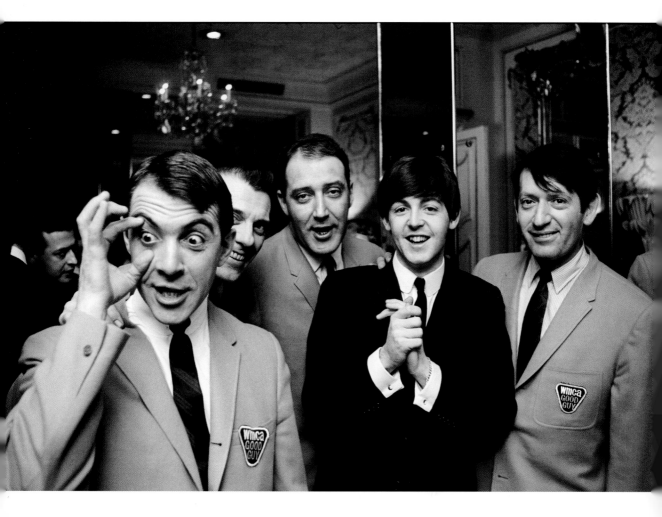

Paul with the WMCA "Good Guys" radio DJs (left to right: Johnny Dark, Joe O'Brien, Jack Spector, and B. Mitchel Reed). Fellow "Good Guys" DJ Harry Harrison can be seen in the photograph on the previous page, on the far right.

Opposite (left to right): Dorothy Kilgallen, *New York Journal American* columnist and *What's My Line* TV show panelist; Chris Welles and Gail Cameron, *Life* reporters; Jane Howard, *Life* correspondent and writer.

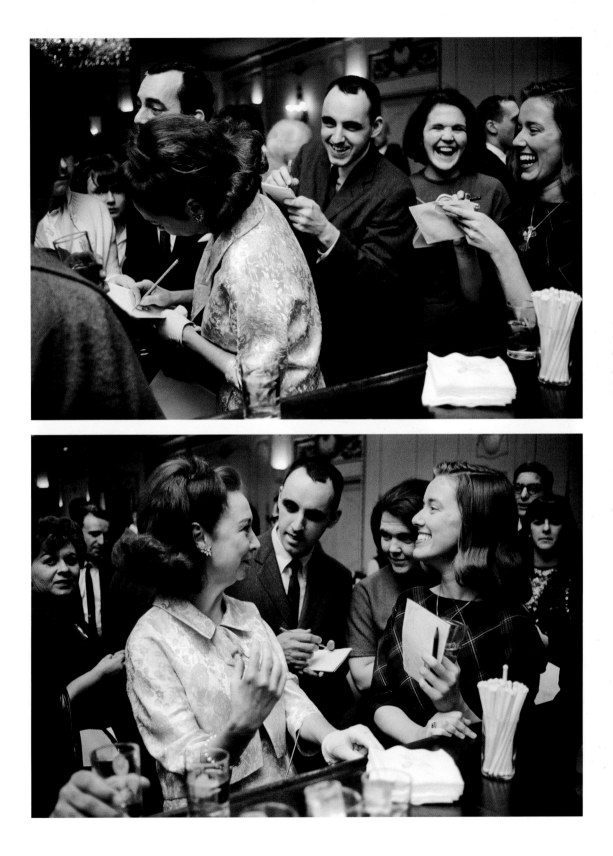

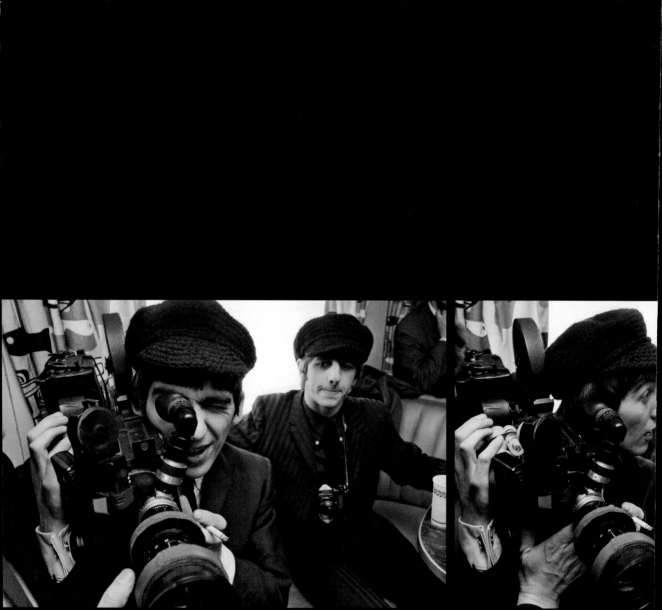

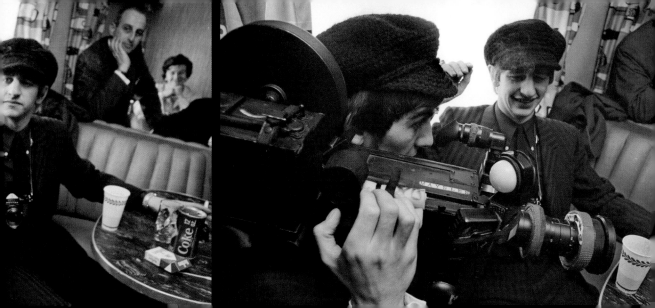

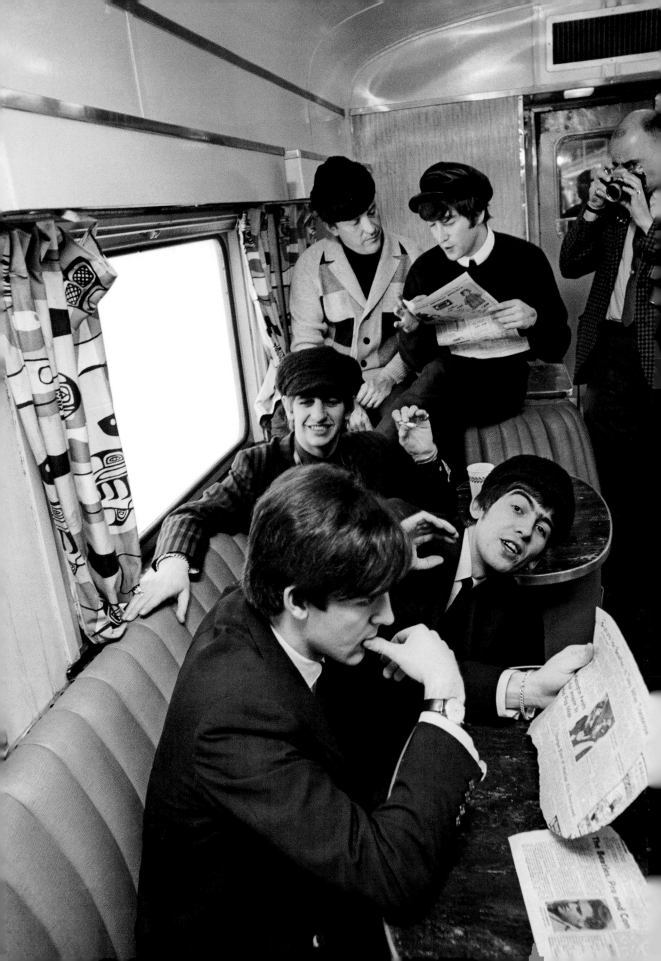

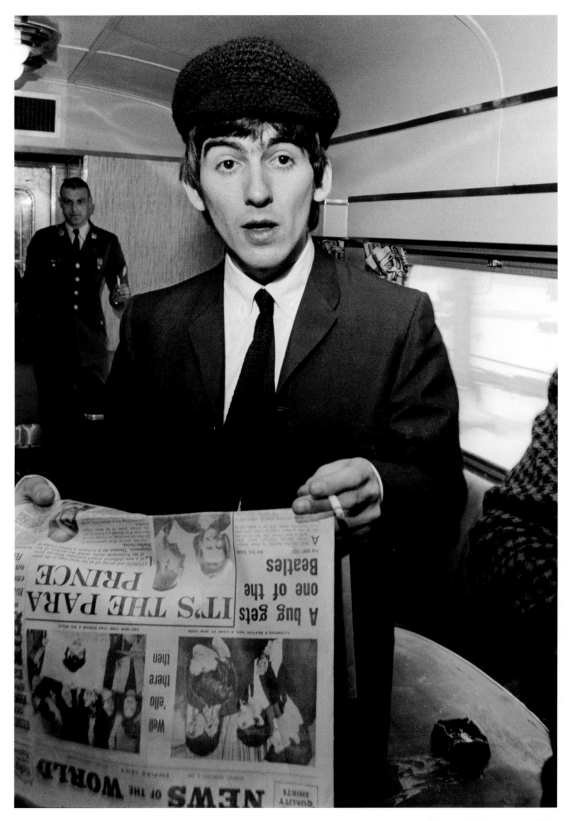

George holds a copy of the *News of the World* with an article written about him titled "A bug gets one of the Beatles."

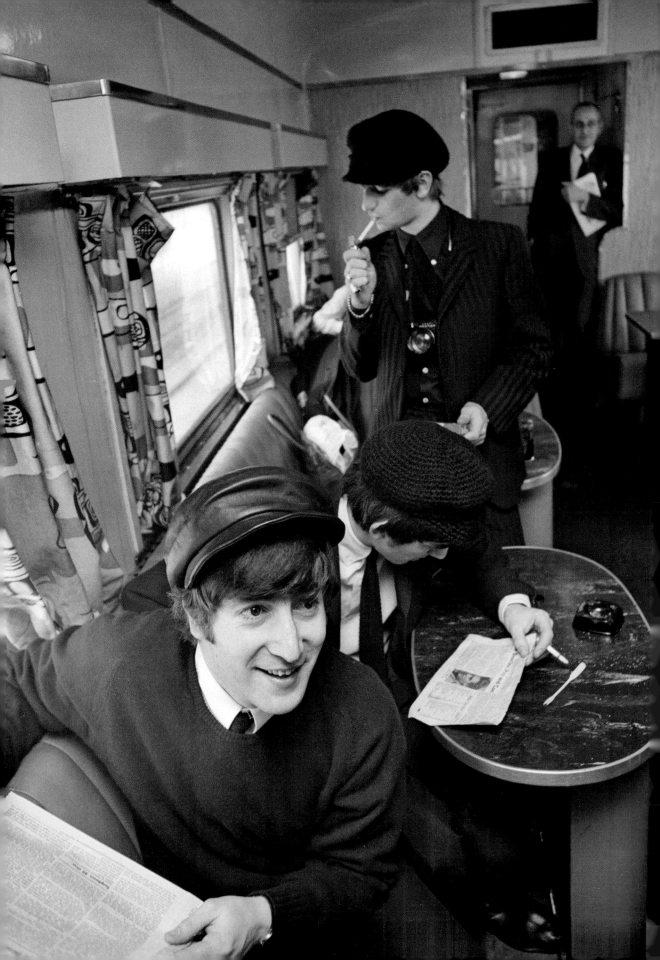

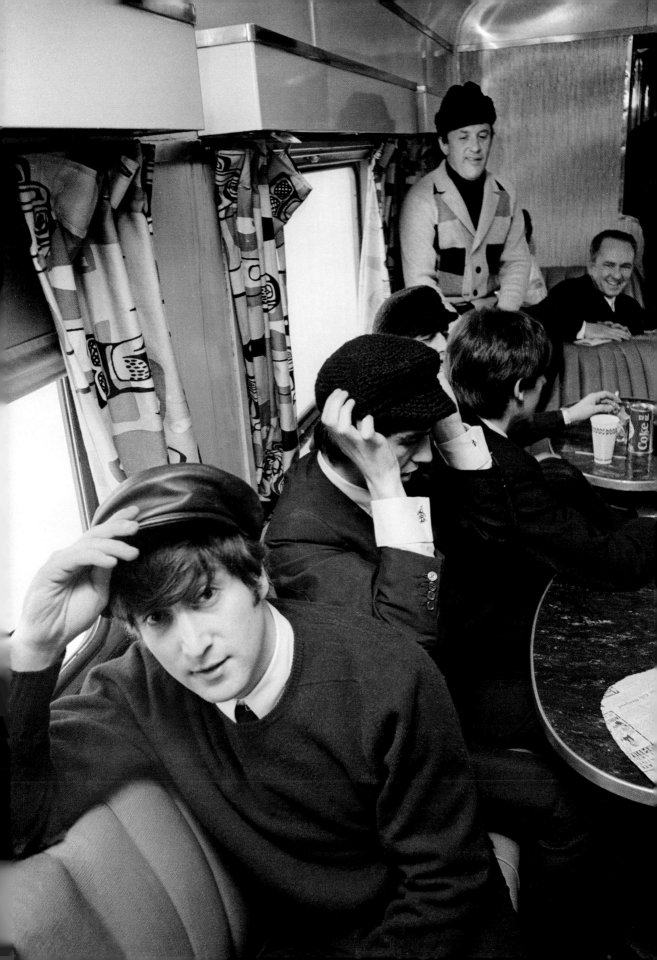

Paul with actress Jane Asher.

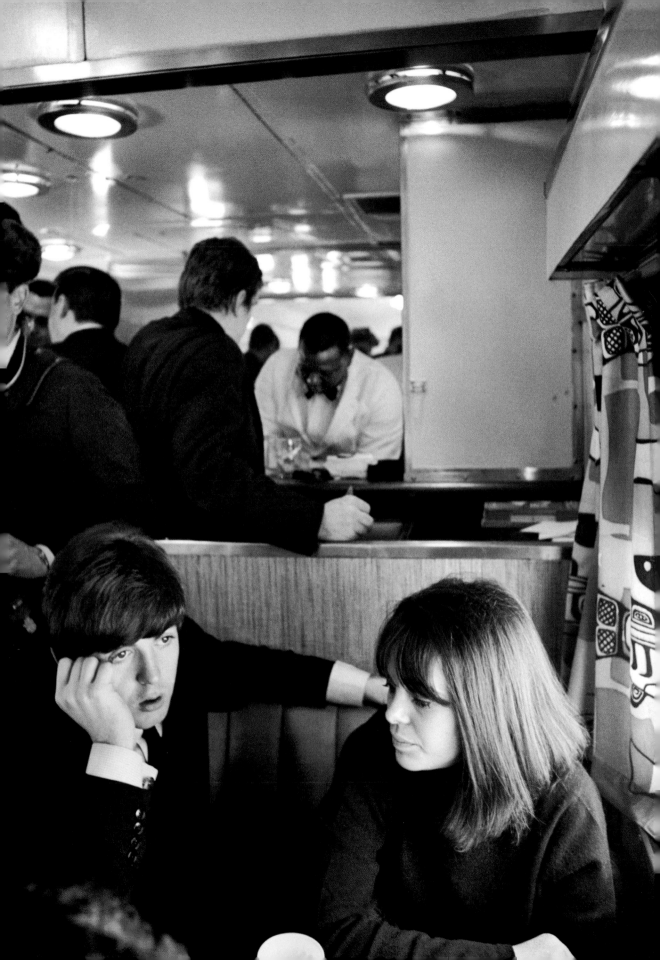

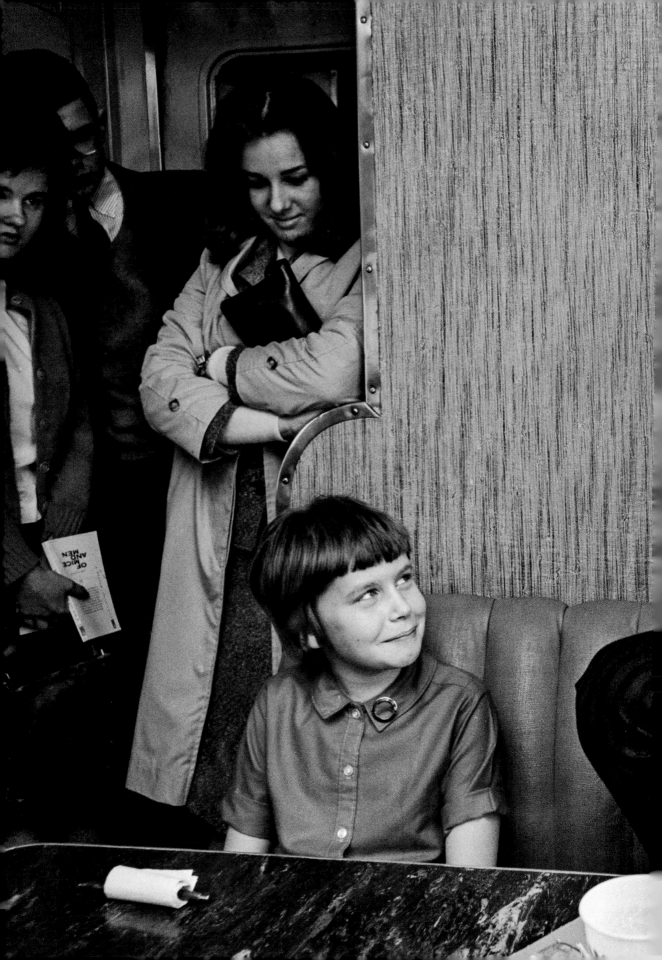

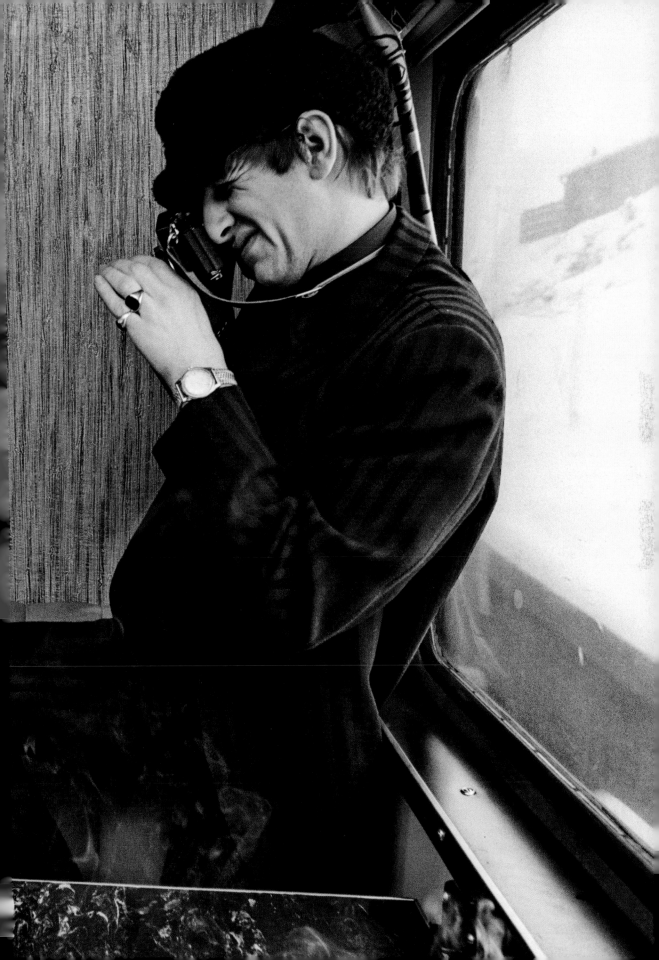

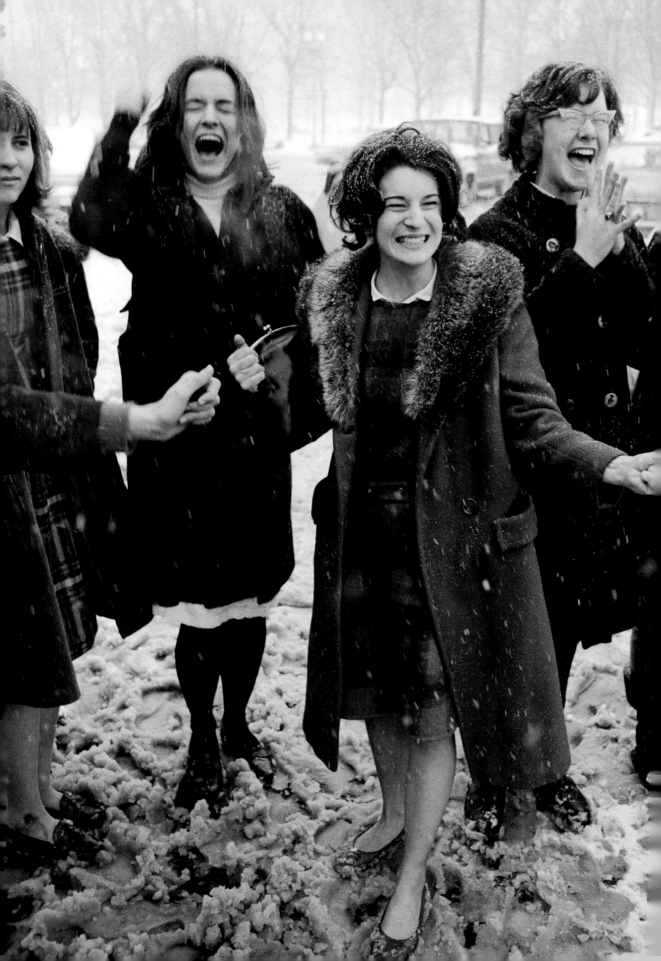

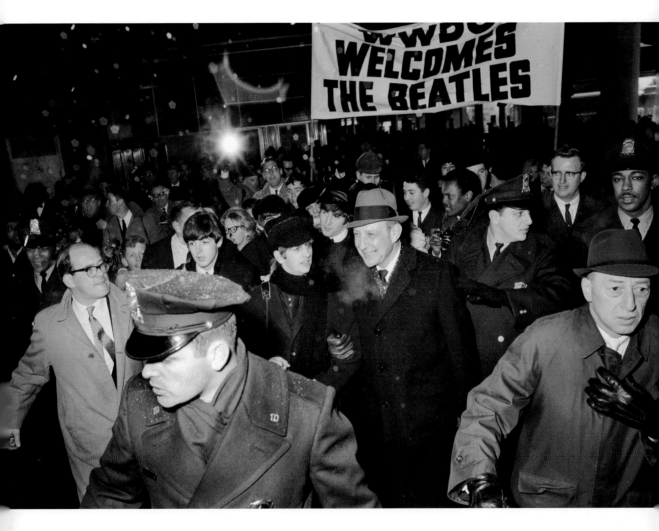

Press, fans, and WWDC radio employees greet the Beatles in Washington, DC. WWDC was the first major US station to play a Beatles record when it played "I Want to Hold Your Hand" in December 1963.

Following pages: The Beatles at a press conference held at the Washington Coliseum; a vendor wearing a Beatles wig sells misspelled pins in the lobby; fans at the Washington Coliseum concert; a private security guard with bullets in his ears to muffle the noise of screaming fans during the concert.

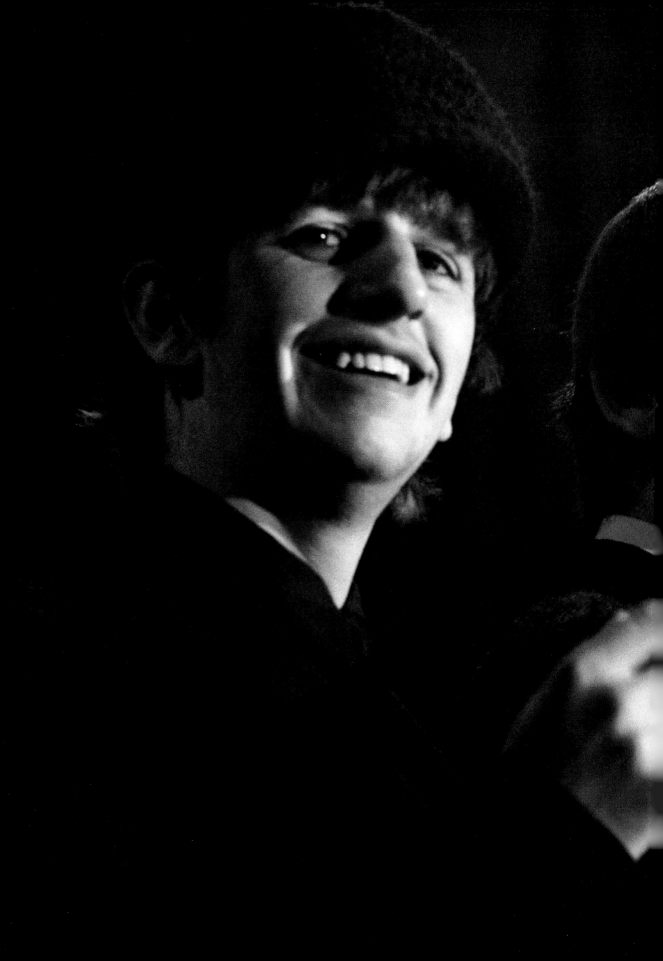

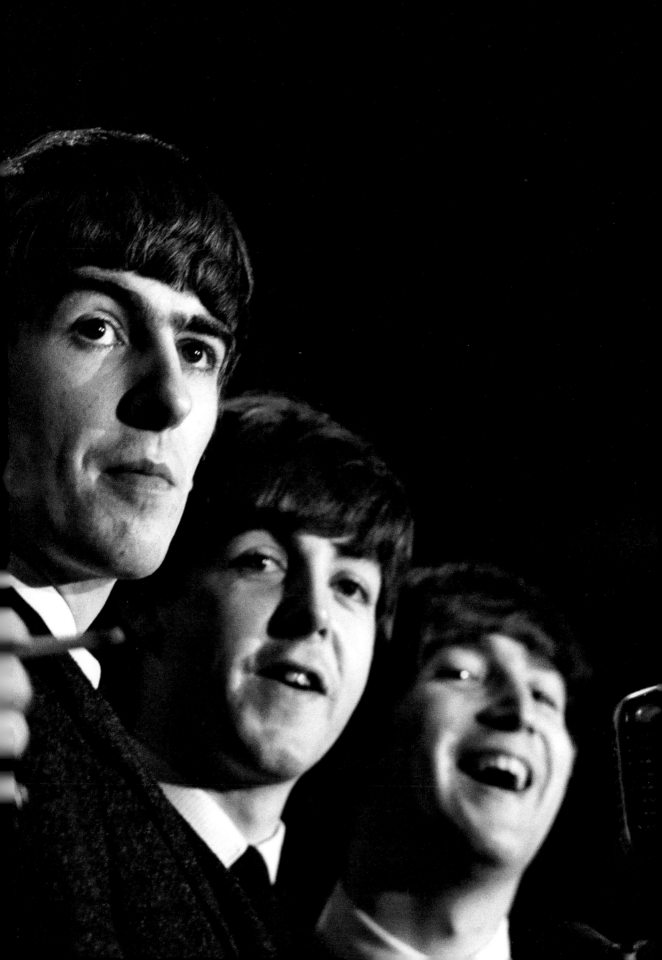

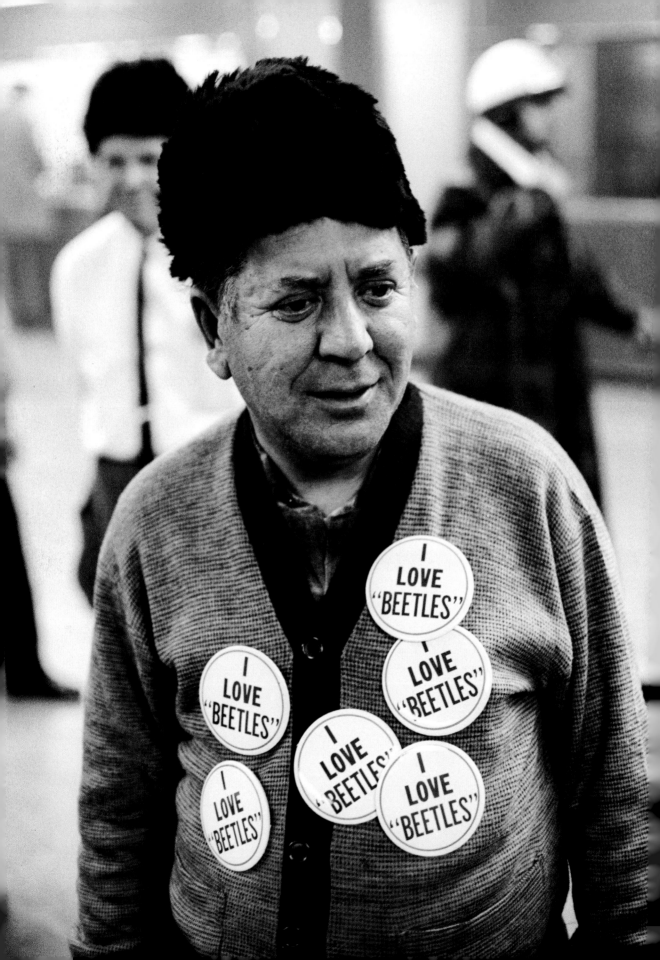

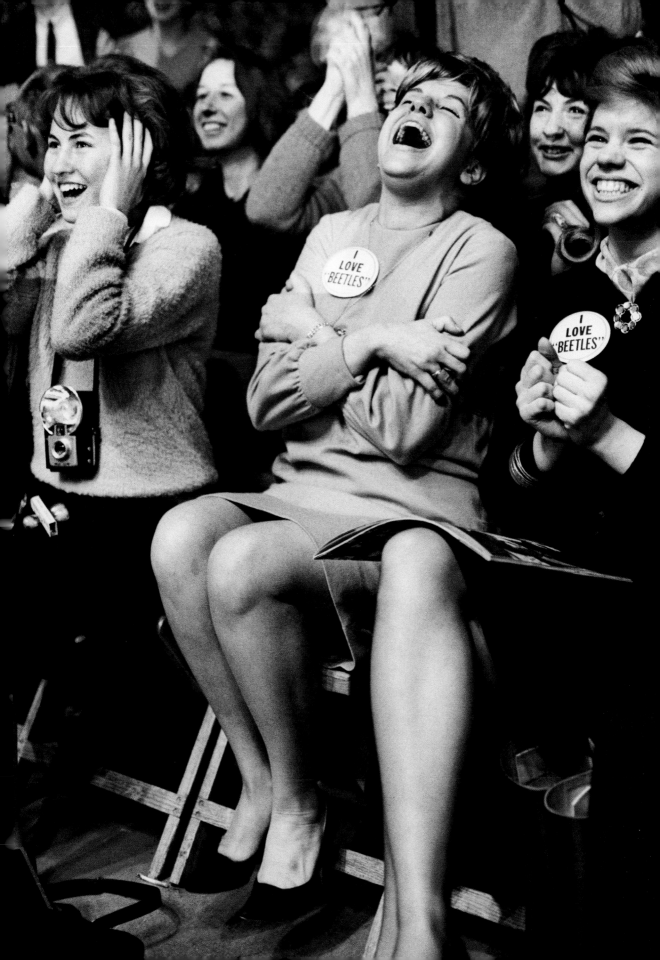

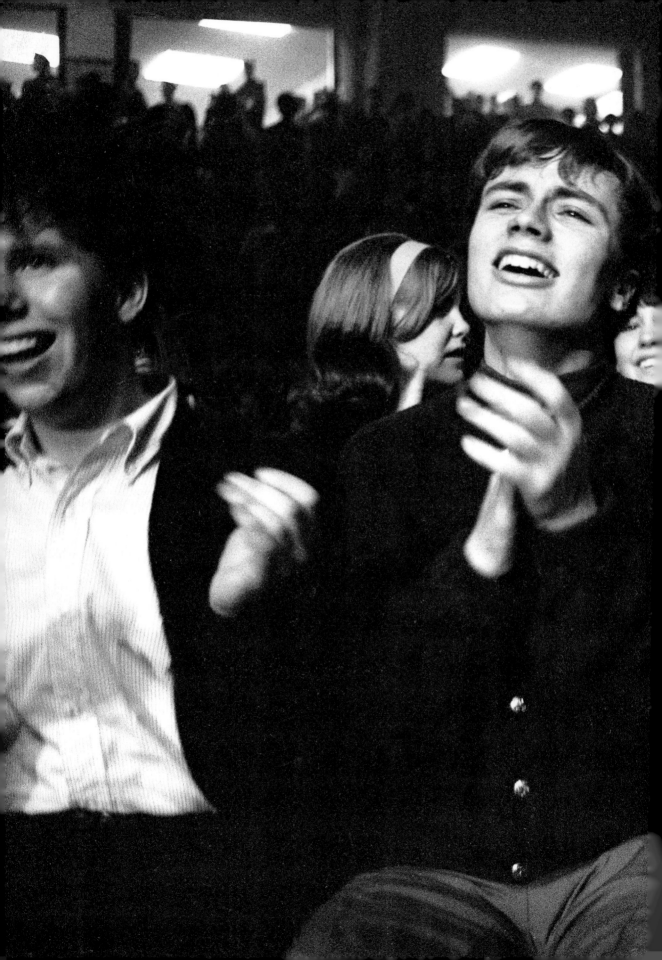

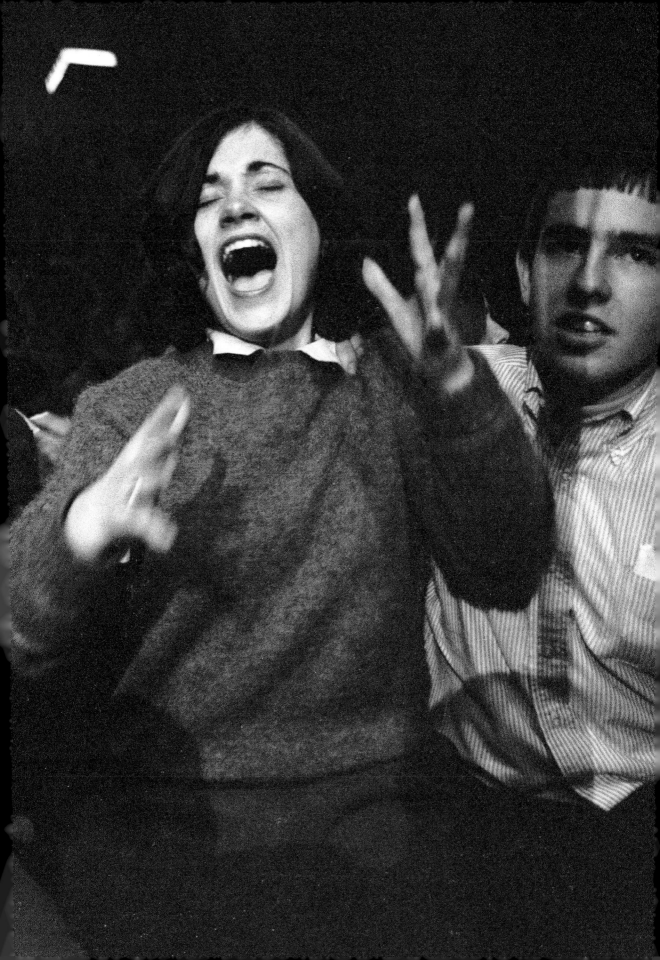

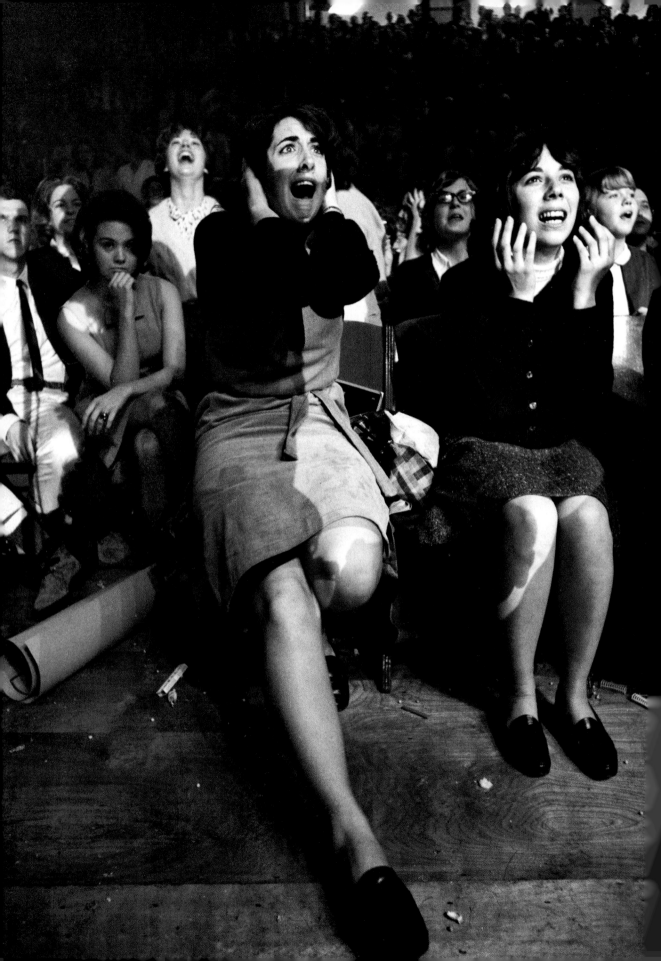

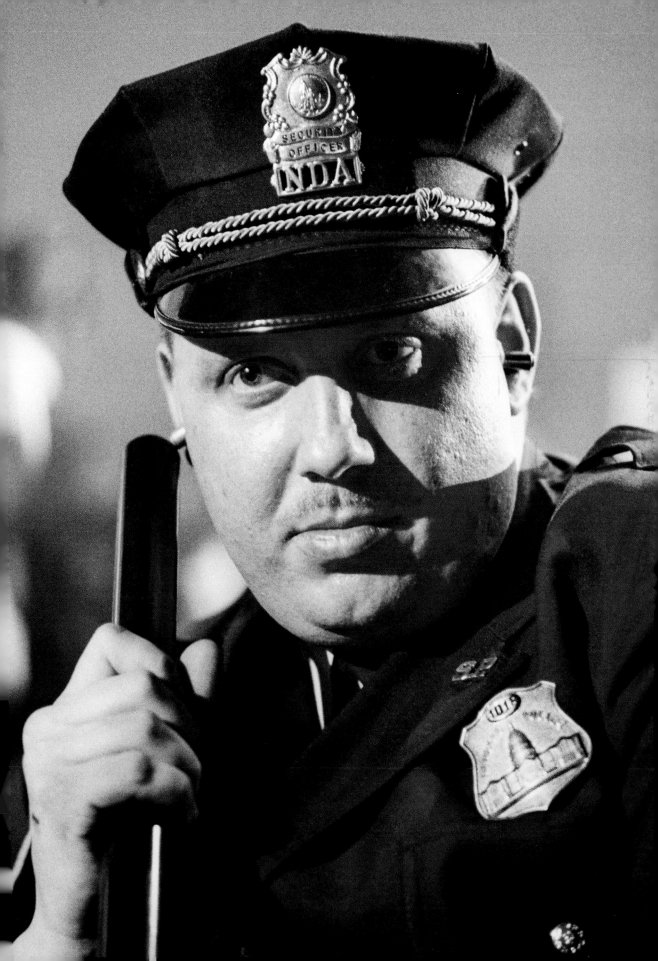

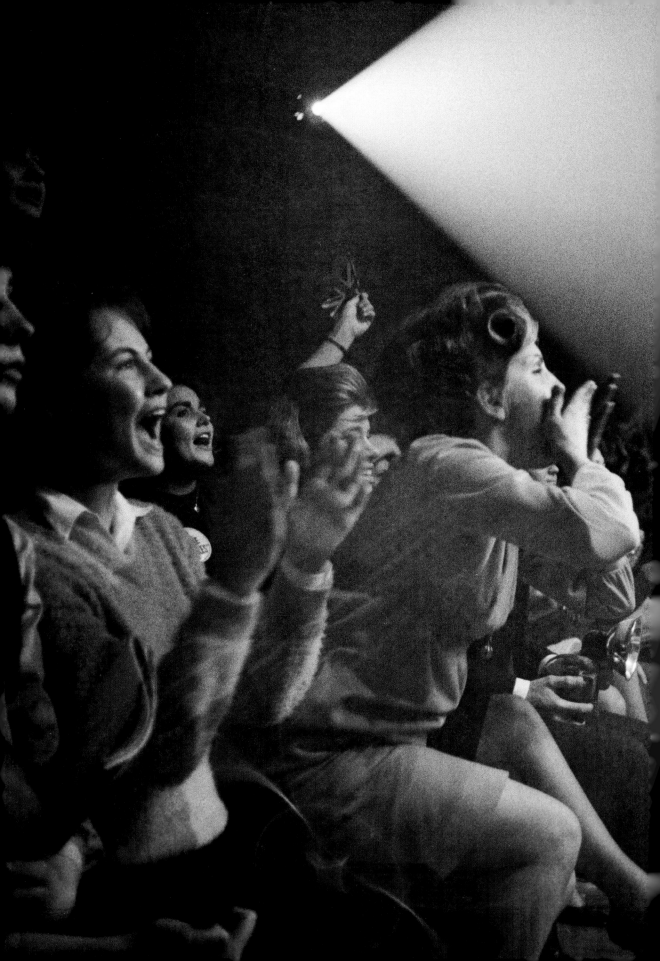

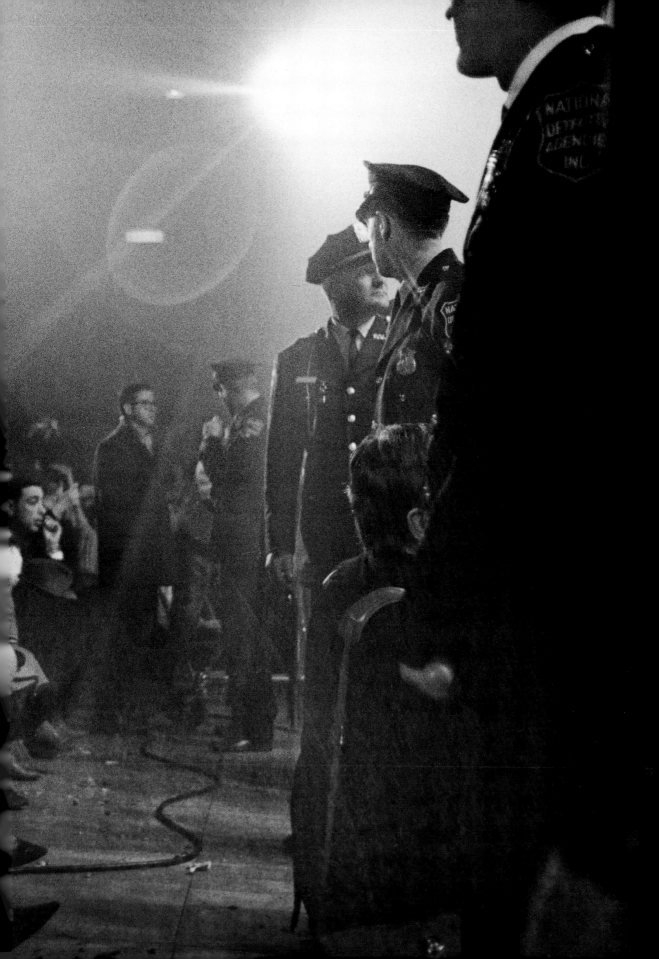

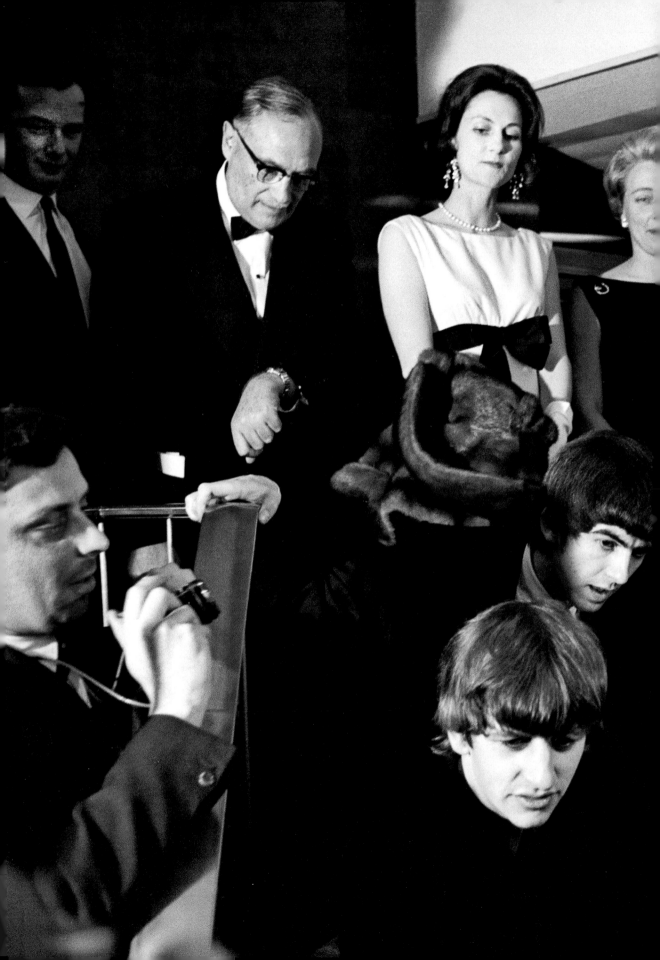

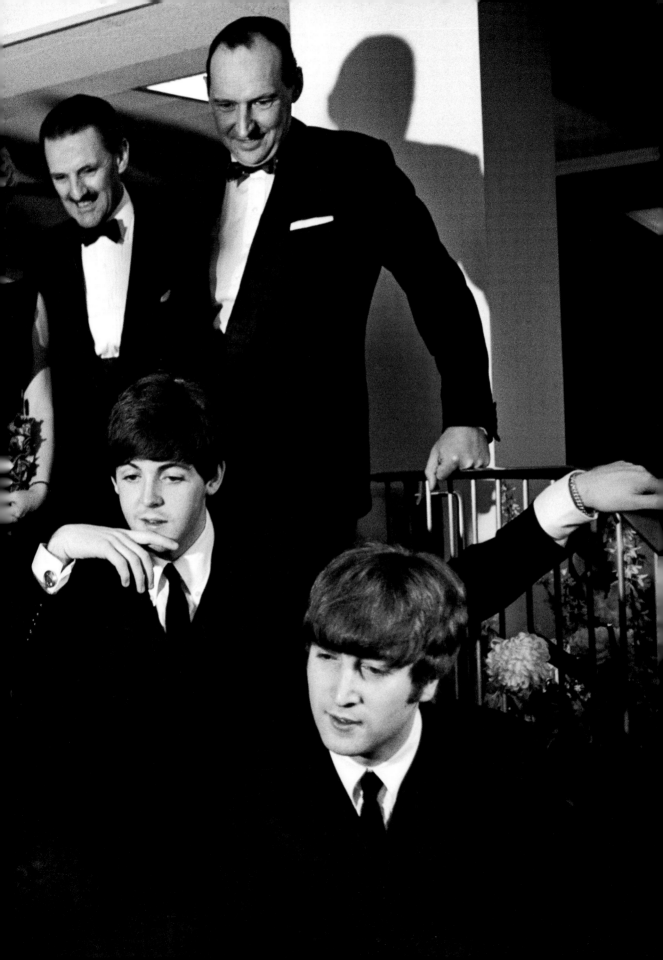

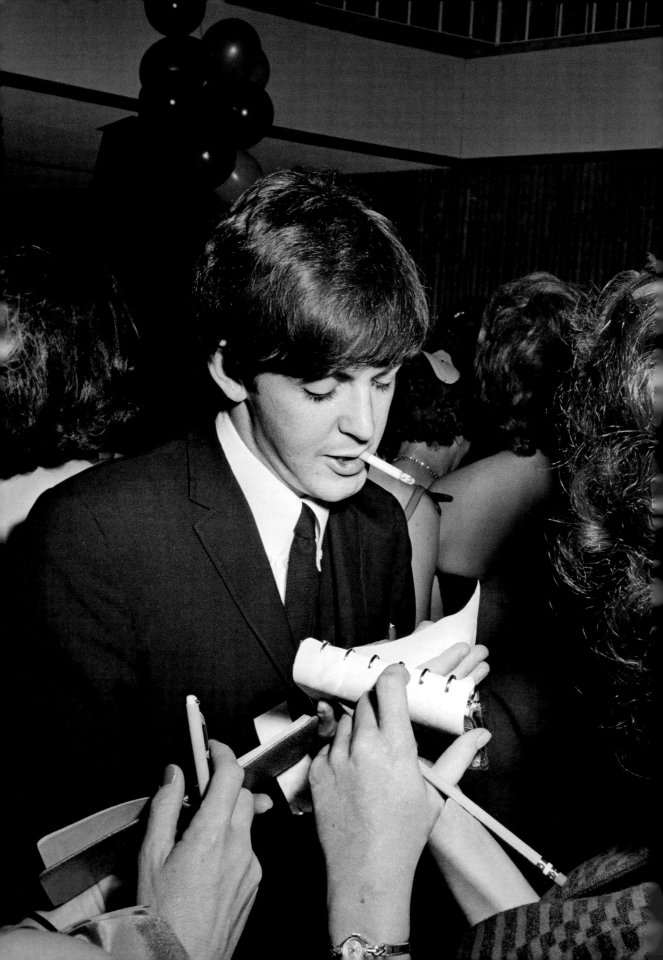

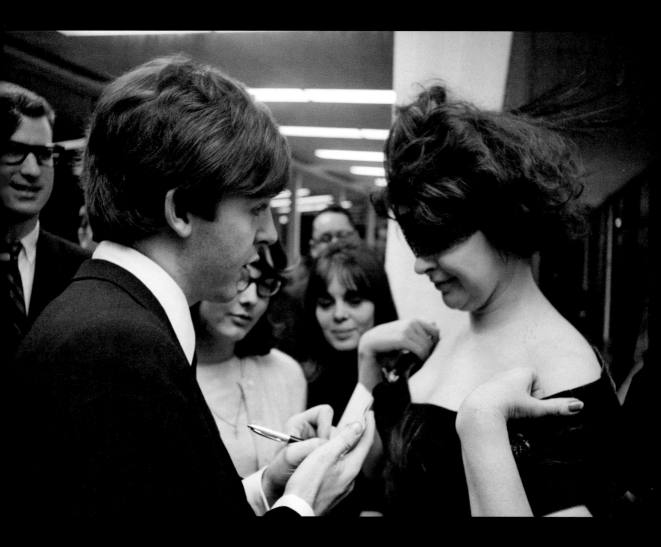

Preceding pages: After the concert the Beatles were guests at the British Embassy Charity Ball. Lady Ormsby-Gore, her husband, Ambassador David Ormsby-Gore, and Brian Epstein stand behind the Beatles.

Overleaf: The Beatles announce the winners of a raffle.

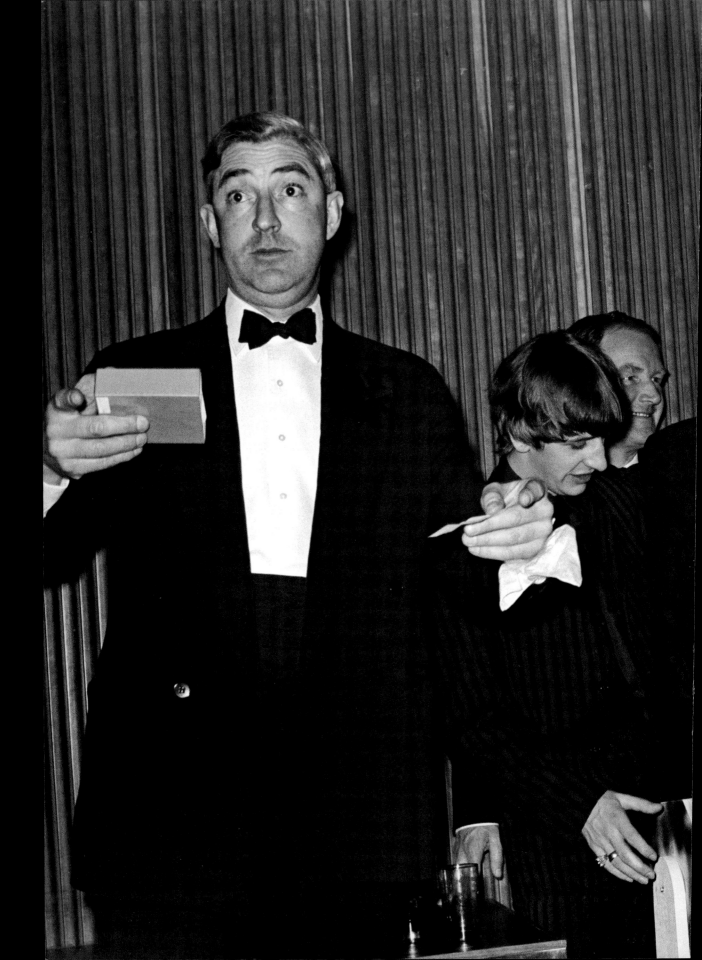

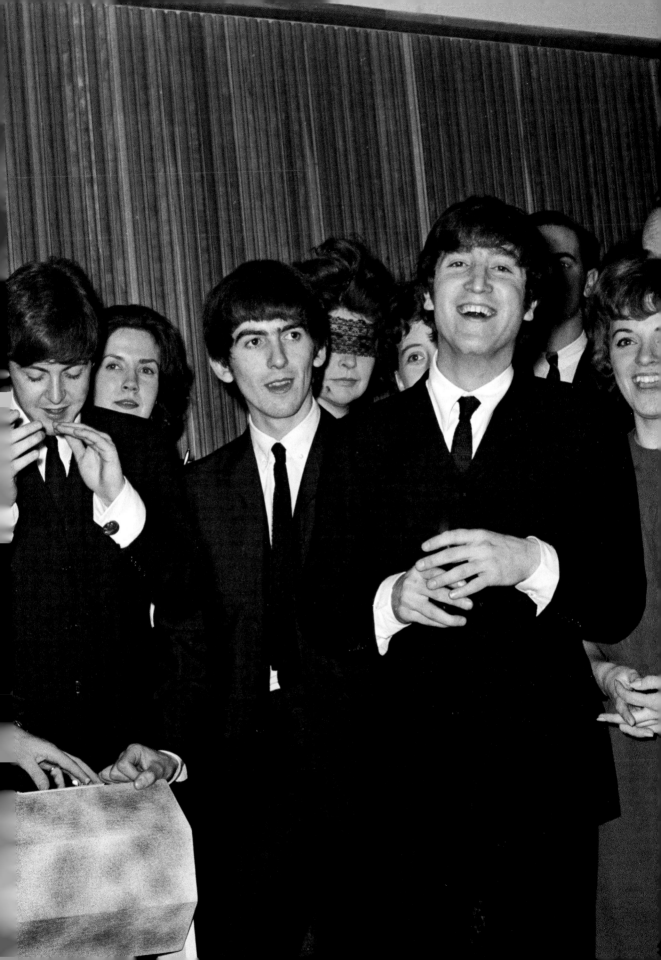

Raffle winners receive
signed copies of the
album *Meet the Beatles!*

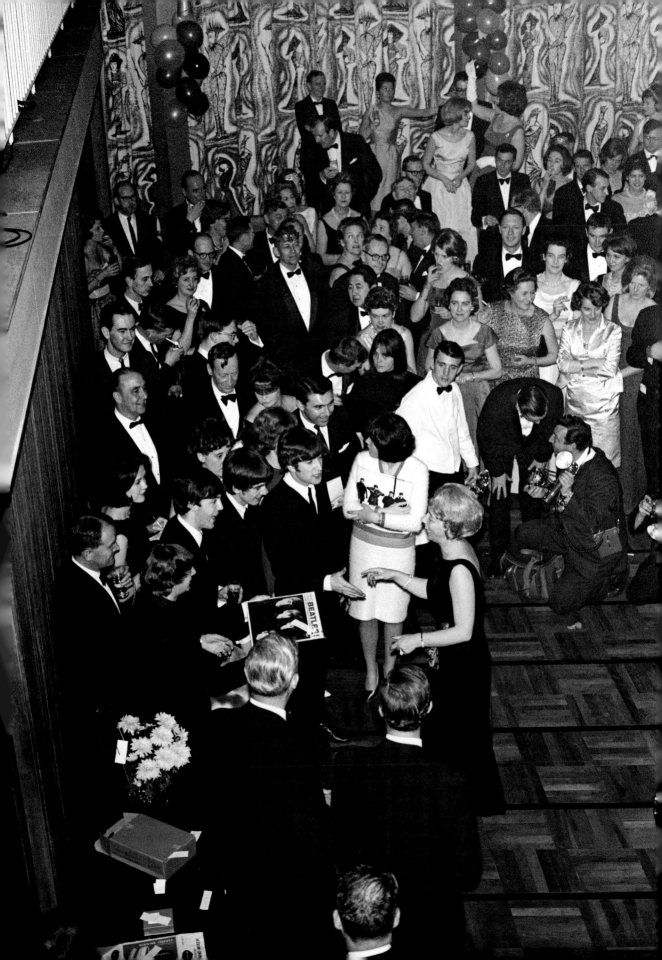

# DAY 6

On Wednesday,
February 12, the
Beatles leave
Washington, DC,
to return to New
York to perform at
Carnegie Hall.

Opposite: Ringo and
Paul take a last look
from the rear car of the
train before departing
Union Station.

Following pages:
The Beatles and
fellow passengers
on the train.

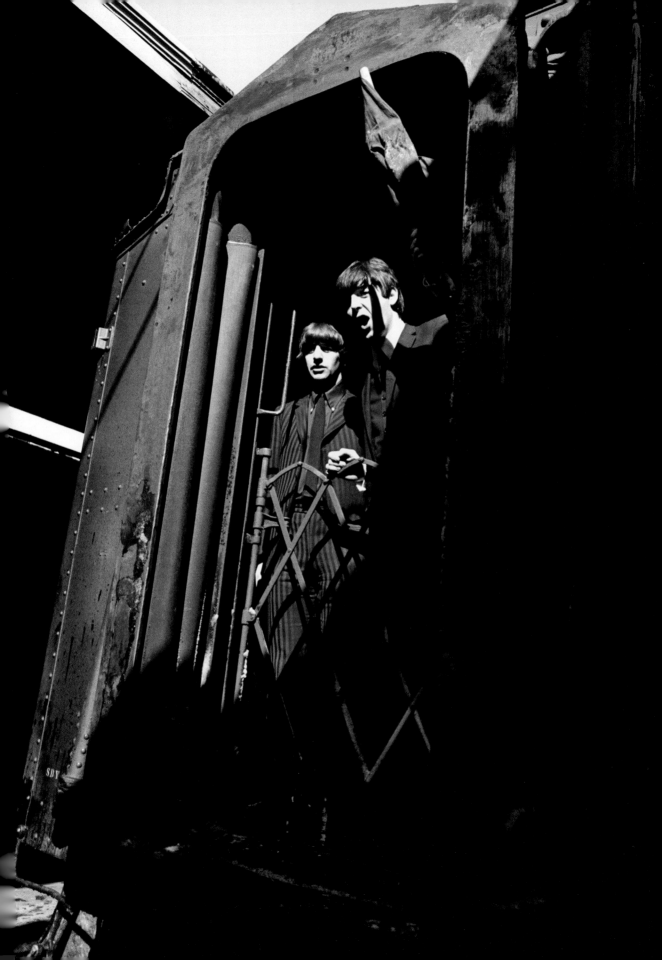

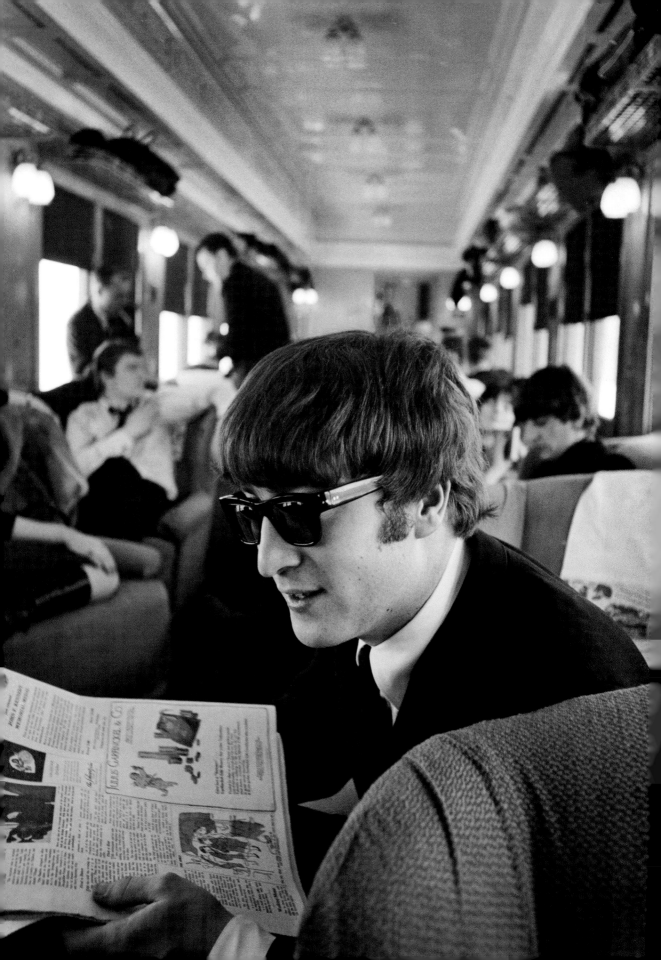

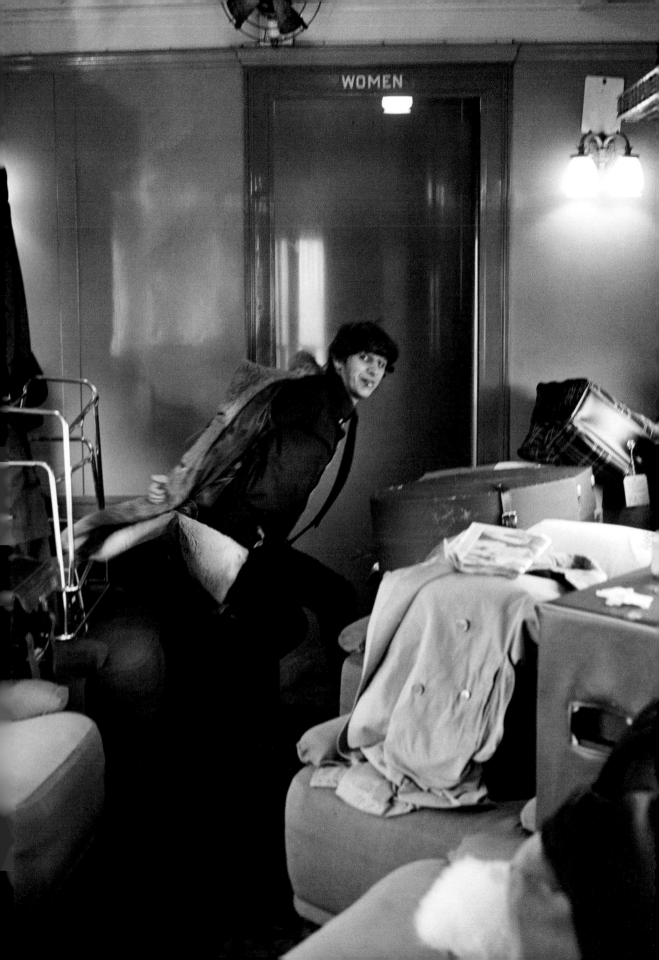

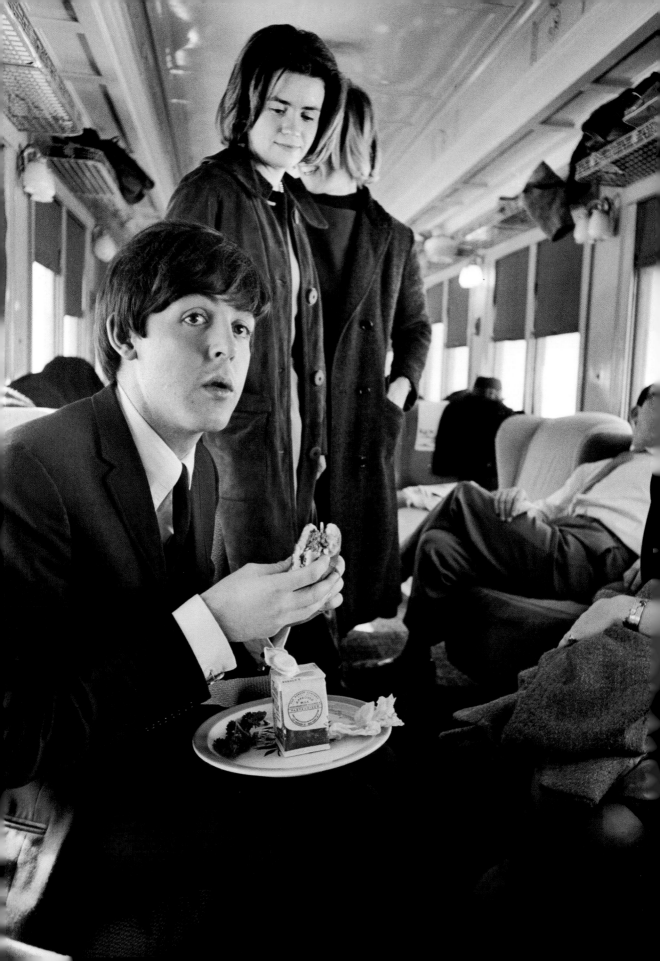

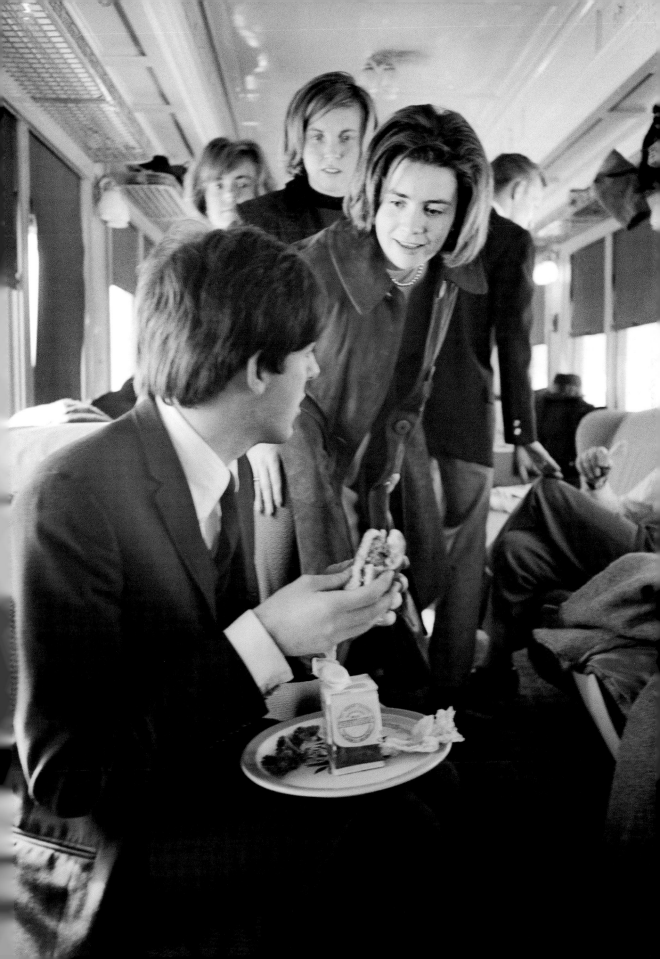

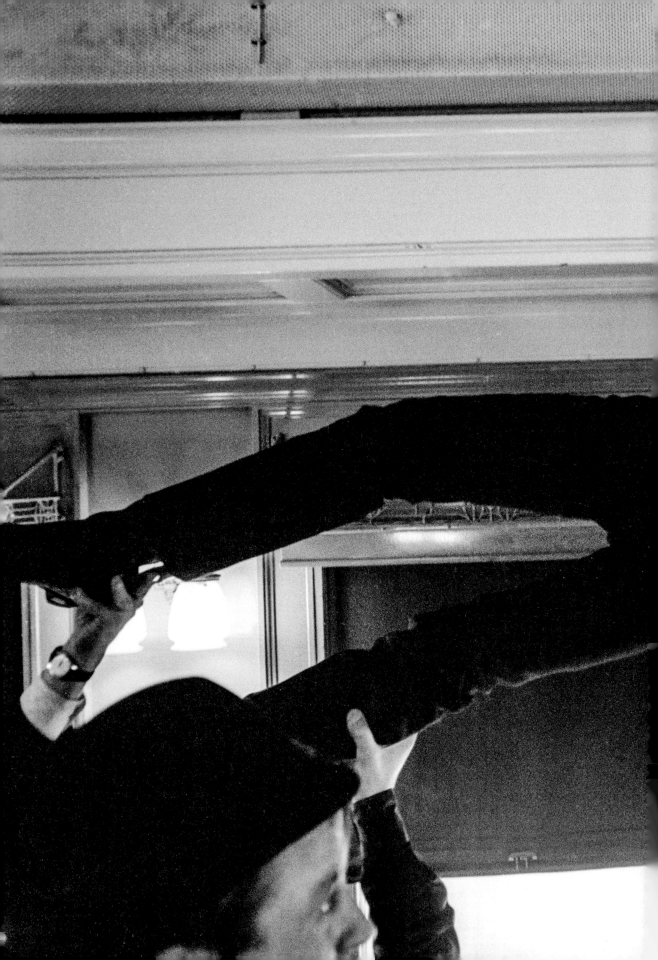

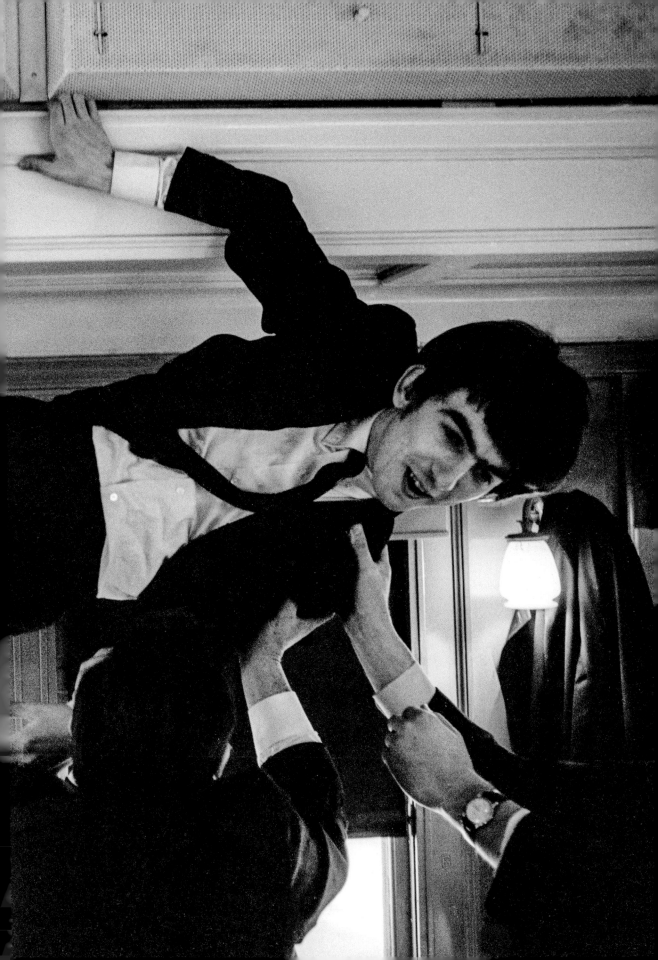

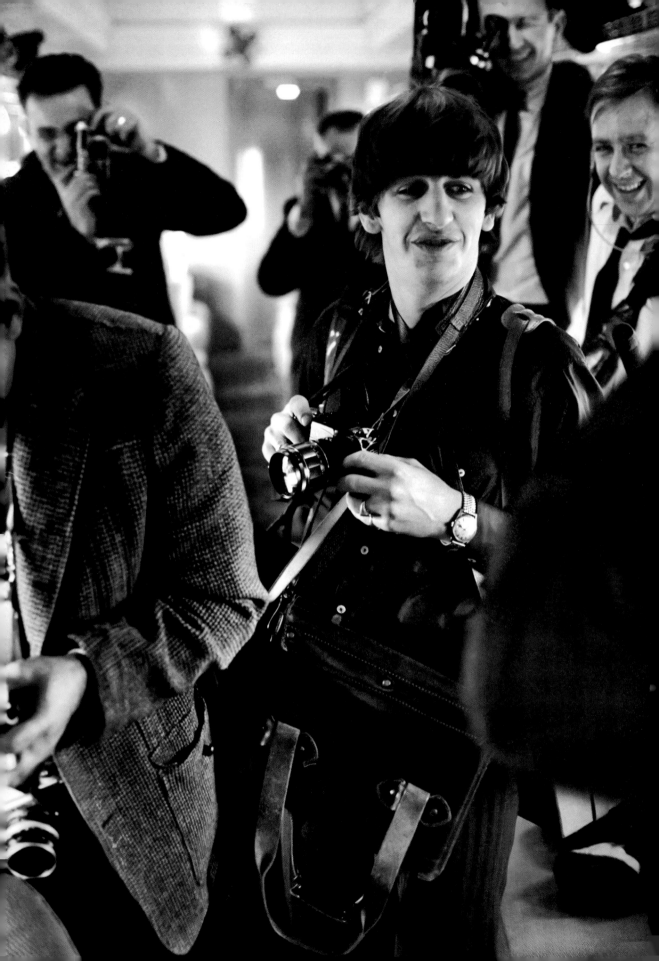

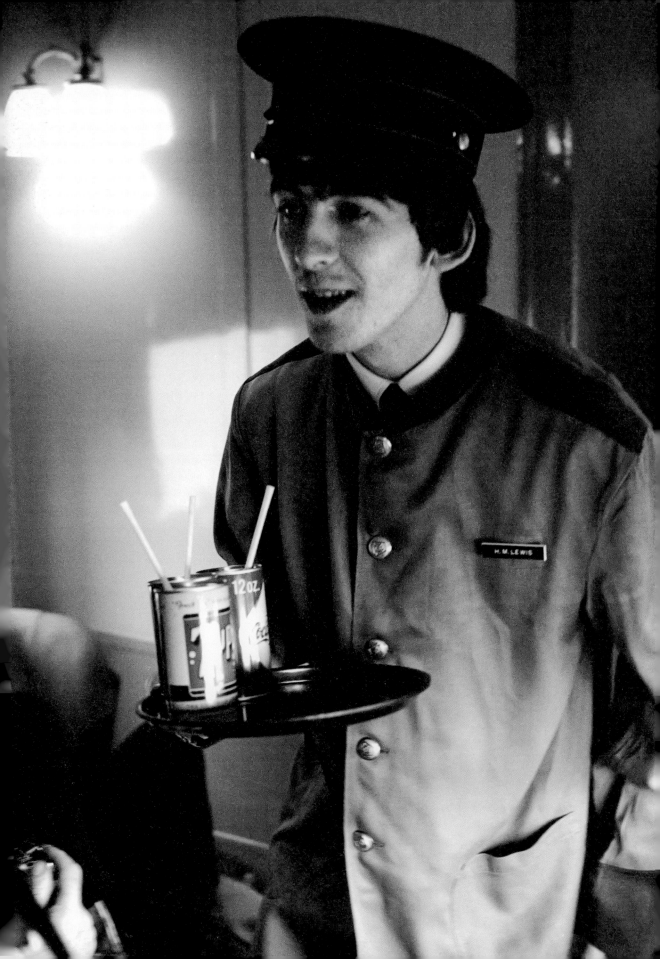

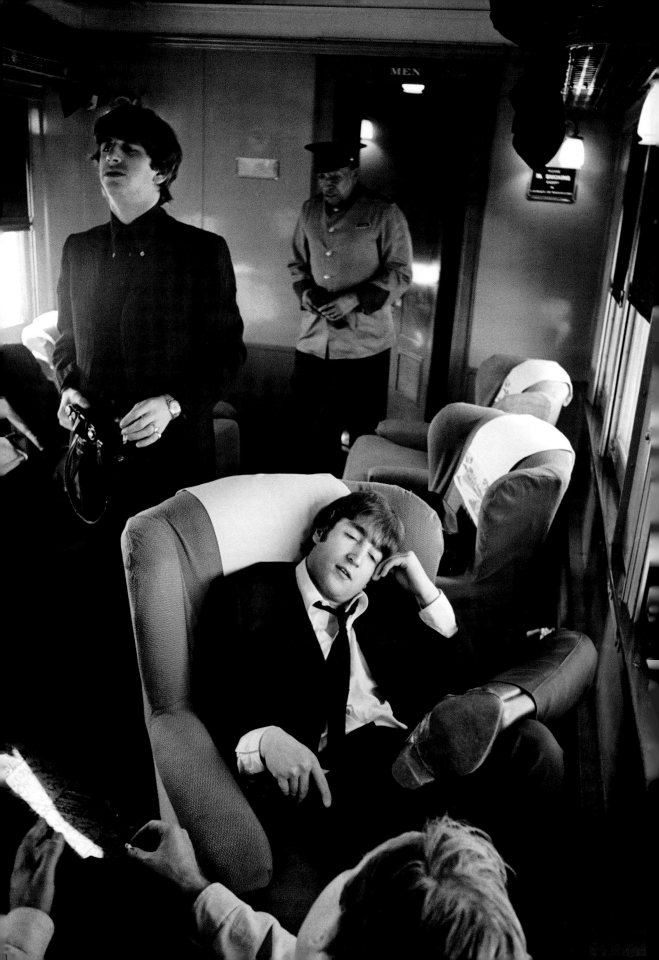

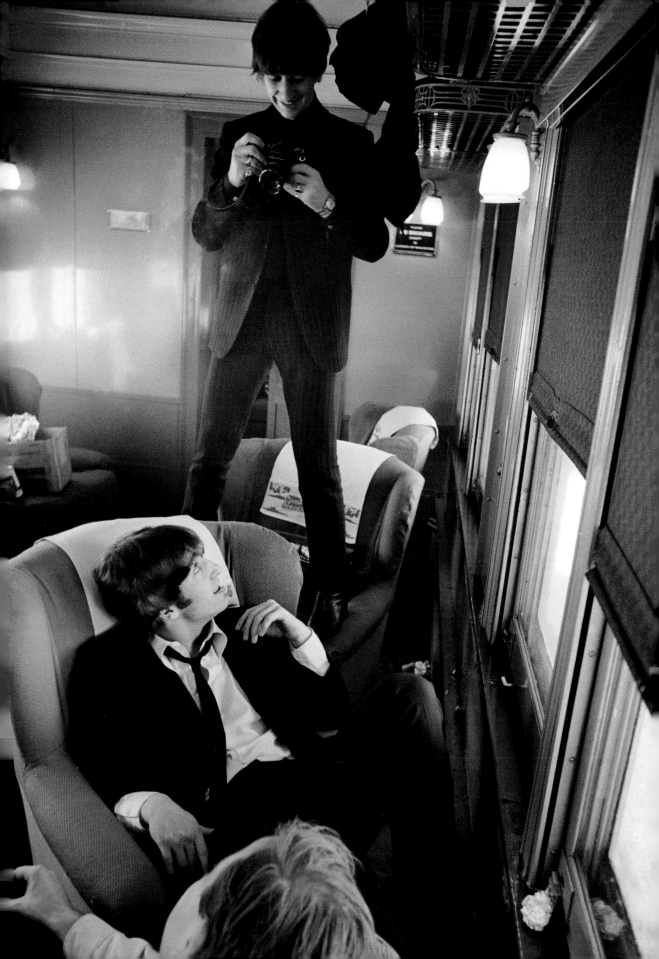

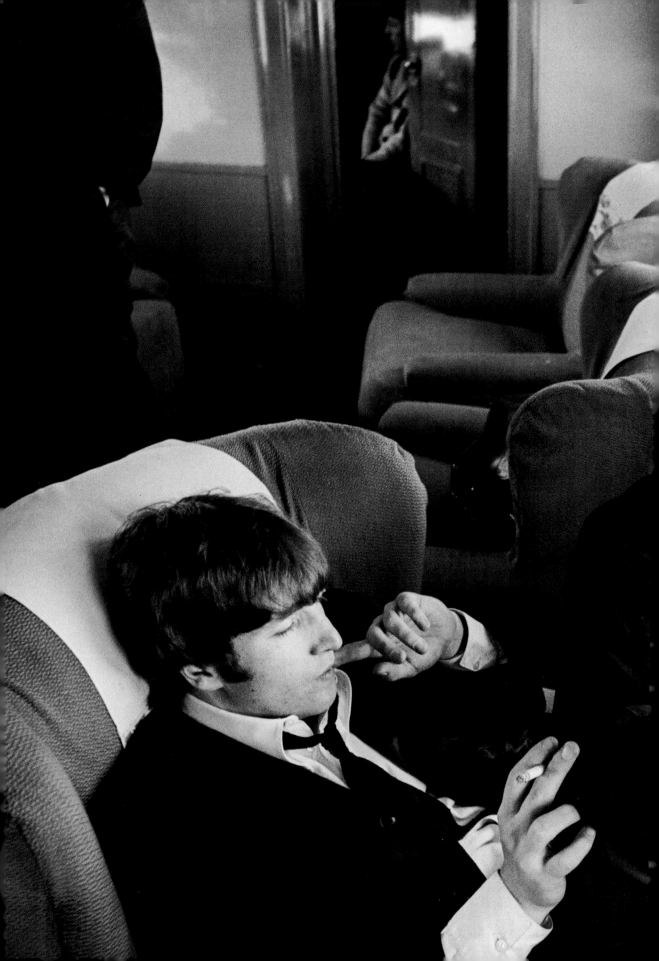

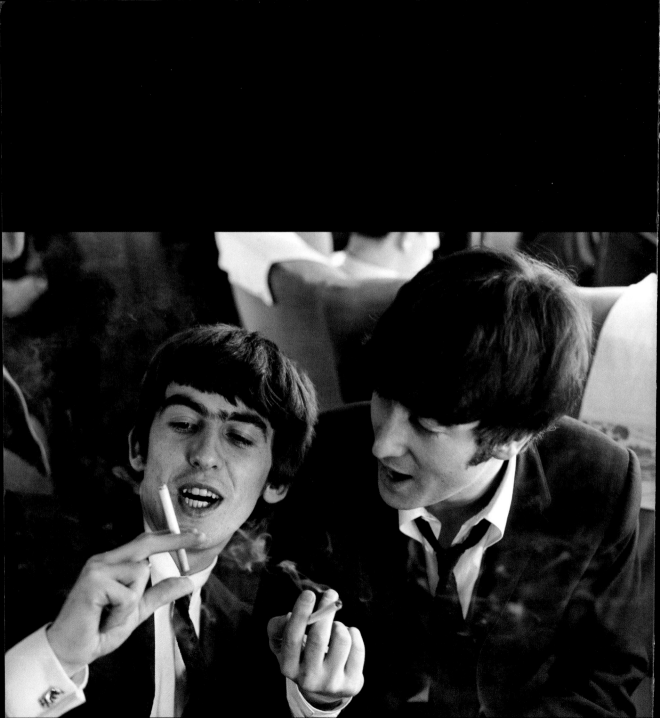

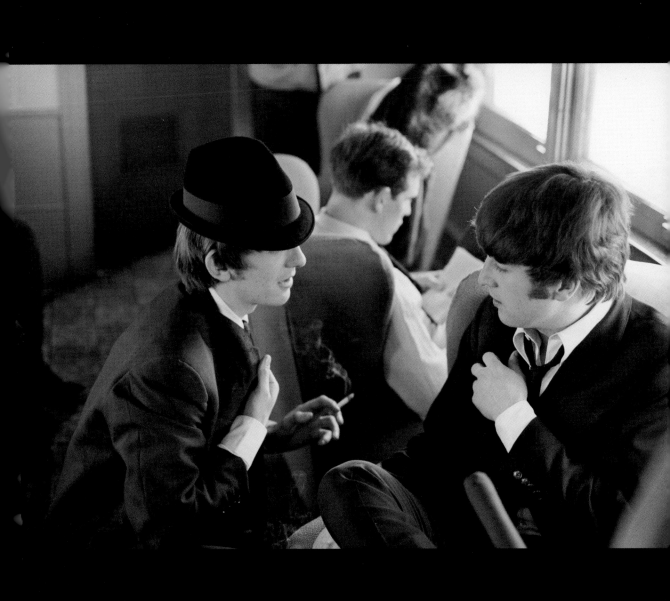

The Beatles waiting to disembark as the train
pulls into New York's Penn Station.

Overleaf: The Beatles onstage at one of the
two concerts they performed at Carnegie Hall
during the evening of February 12.

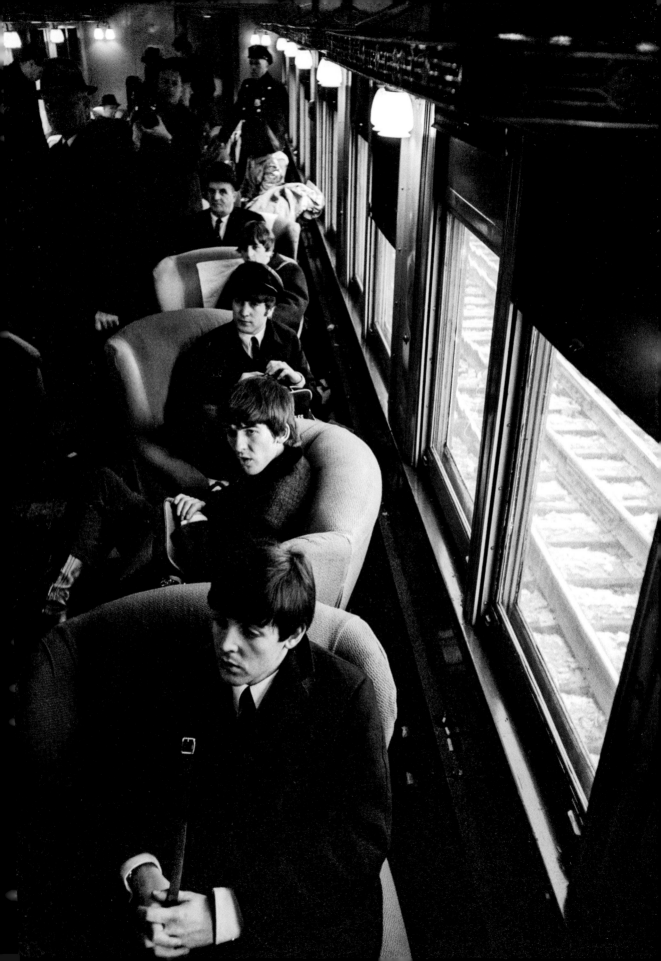

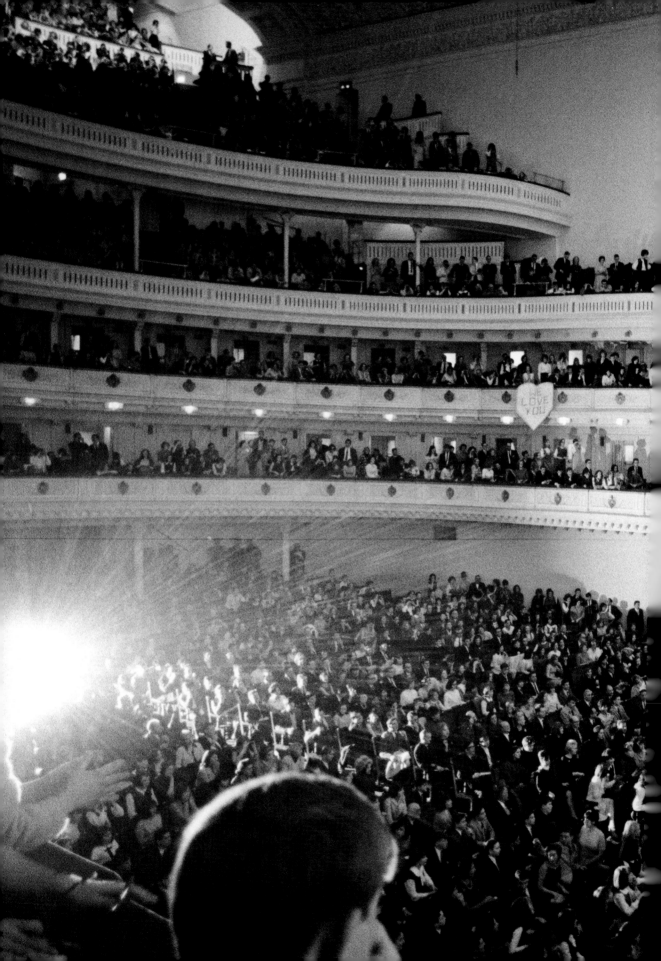

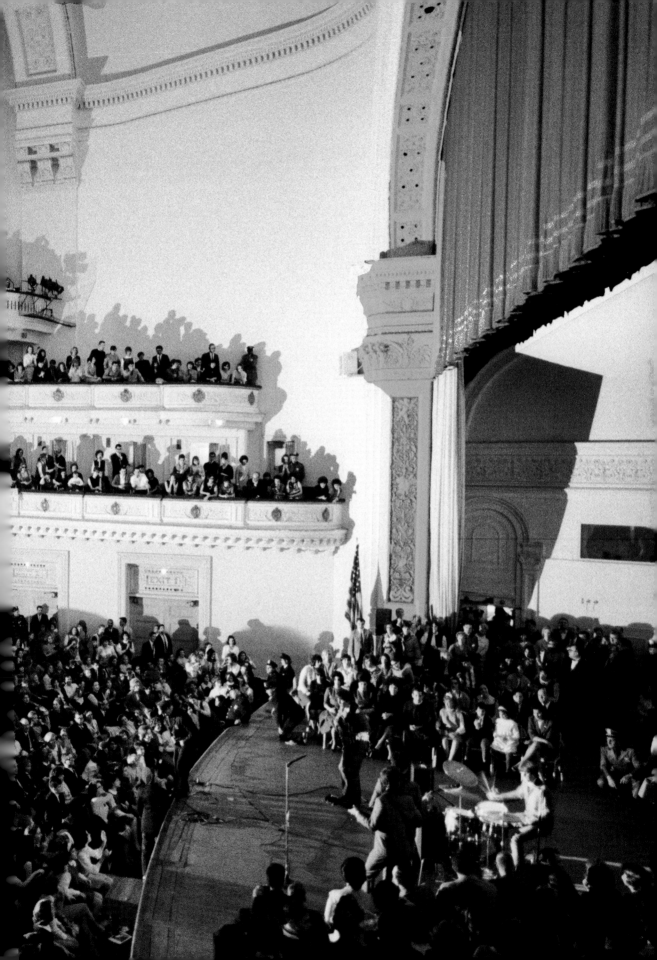

# ACKNOWLEDGMENTS

I did not write captions or take notes when I photographed the Beatles in 1964—that was the job of the *Life* magazine reporter. The dates and events of those six days in February needed to be checked for accuracy. I could not rely on other books for reference because we found too many published contradictions in the timeline from February 7 through February 12. My recollection of each day was not accurate either. I owe so much to my wife and editor, Adrienne Aurichio, who spent weeks going through the three thousand images on ninety rolls of film to piece together my story. I relied on her vision and experience as an editor to research and unravel the photographs, and then pull them together in chronological order.

The documentary *The Beatles: The First U.S. Visit* is a superb chronicle of Beatlemania and was invaluable in helping to identify some of my photographs. I thank Albert Maysles and his late brother, David, the filmmakers responsible for it. We all tried to stay out of the others' way during that time but I ended up in their film, and they in my photographs.

Bruce Spizer, author and expert on Beatlemania, was extremely generous with his knowledge and supplied the missing pieces of the puzzle that enabled us to finish the chronology.

I would like to thank Rankin for his really fine introduction. I am quite moved by his words. He has said some things that we all should realize about our profession. Perhaps in a world like this we should also understand exactly what our roles are, and be able to explain what we see. Photographic journalists are the visual historians of these times.

Many people helped along the way including Jim Cornfield, author and photographer, who introduced me to Rizzoli. Alyssa Adams of the Eddie Adams Workshop, and publicist Judy Twersky were also very generous with their time. I have used Nikon cameras for more than fifty years and the company has provided support in numerous ways. Their staff, Mike Corrado, Melissa DiBartolo, Steve Heiner, Bill Pekala, Lindsay Silverman, Mark Suban, and many others have all been there for me. Marc Savoia, Catherine Vanaria, and Lys Guillorn of Connecticut Photographics are always willing to offer their expertise. I am also grateful to the enthusiastic supporters of my work, Ed Macedo and Susie Kamb, Sid and Michelle Monroe of Monroe Gallery, John Filo of CBS, Bobby Baker Burrows and Russell Burrows, and the Eppridge, Norum, and Aurichio families.

Rizzoli's excellent team led by Charles Miers guided this project and made it a truly enjoyable experience. Our dedicated and patient editors Daniel Melamud and Robb Pearlman were there whenever we needed them, and were partners in crafting this book. They both have a love of photography, and they worked with us to develop an idea that began many months ago. Thank you also to Lynn Scrabis, Maria Pia Gramaglia, Jessica Napp, Colin Hough-Trapp, Elizabeth Smith, Kayleigh Jankowski, Jacob Lehman, and Nick Vogelson, the talented art director who brought the story to life with his brilliant design.

After fifty years I have forgotten some of what happened in 1964. What I can never forget, however, were those four young gentlemen who called themselves the Beatles—thank you for ignoring my cameras as I had asked, and letting me do what I love: make pictures.

Finally, a mention to the unknown person at Time Inc. who had my original negatives in their possession for many years, and wisely returned them to me so that the work could be seen today.

First published in the United States of America in 2014
by Rizzoli International Publications, Inc.
300 Park Avenue South
New York, NY 10010
www.rizzoliusa.com

Photographs and foreword © Bill Eppridge
Introduction © Rankin
Edited by Adrienne Aurichio and Daniel Melamud
Designed by Nick Vogelson

2014 2015 2016 2017 / 10 9 8 7 6 5 4 3 2 1
ISBN-13: 978-0-8478-4105-9

Library of Congress Control Number: 2013943905
Printed in China

A Beatles souvenir book stands out in the crowd of fans as the Beatles arrive at Penn Station.

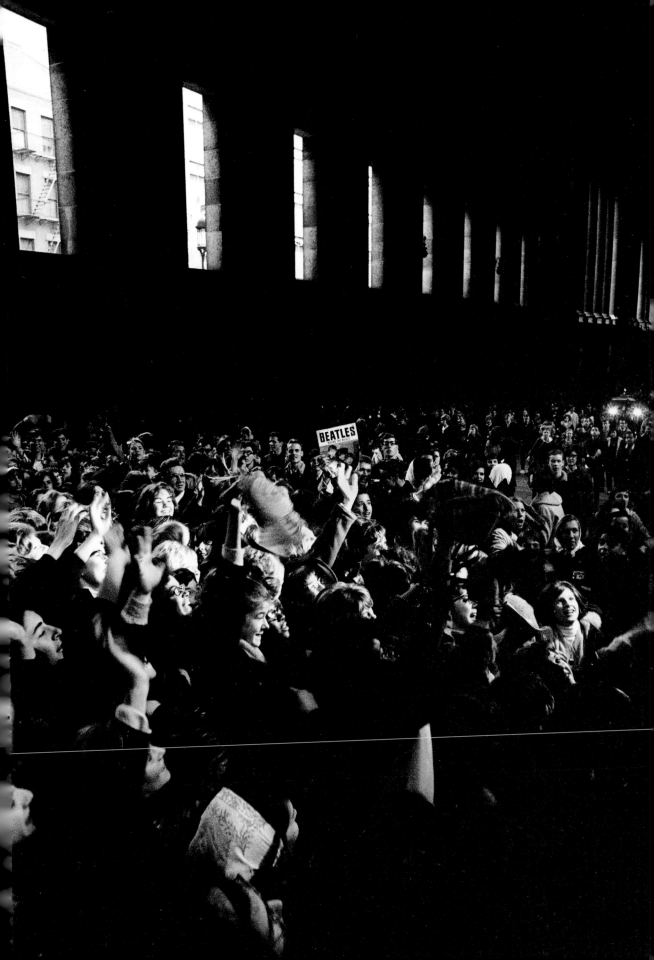

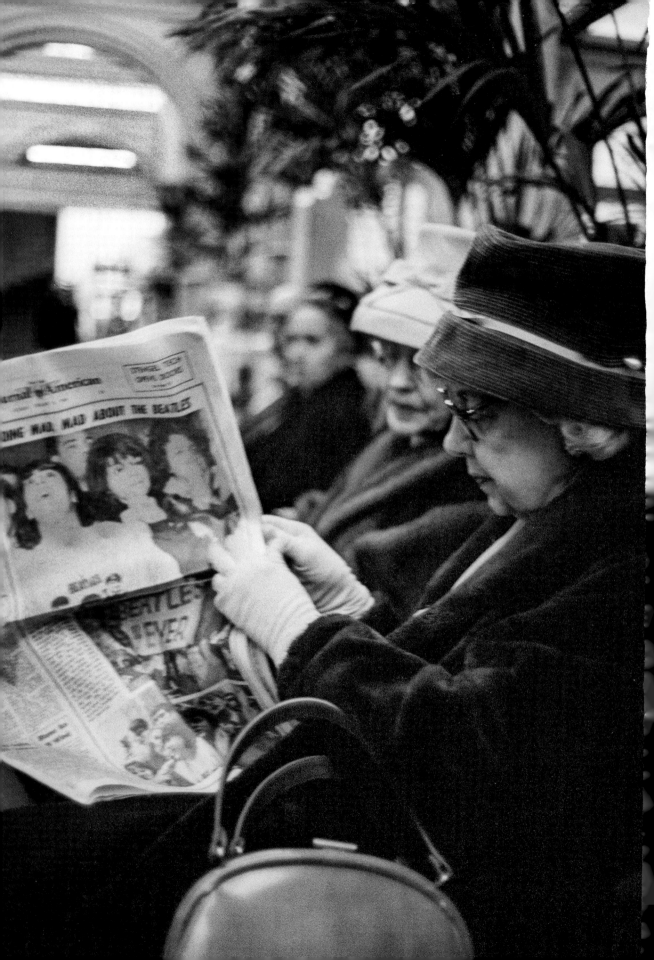

ON FEBRUARY 13, 1964, THE BEATLES FLEW TO MIAMI FOR THE LAST STRETCH OF THEIR FIRST US TOUR. THEY RETURNED TO LONDON ON FEBRUARY 21 ON A PAN AM BOEING 707 RENAMED "JET CLIPPER BEATLES." A RECORD-BREAKING 73 MILLION PEOPLE, NEARLY 40% OF THE US POPULATION, HAD VIEWED THEIR LIVE PERFORMANCE ON *THE ED SULLIVAN SHOW* ON FEBRUARY 9.

THOUSANDS OF FANS WERE AT THE AIRPORT TO SEE THEM GO, THE WORLD FOREVER CHANGED BY BEATLEMANIA.

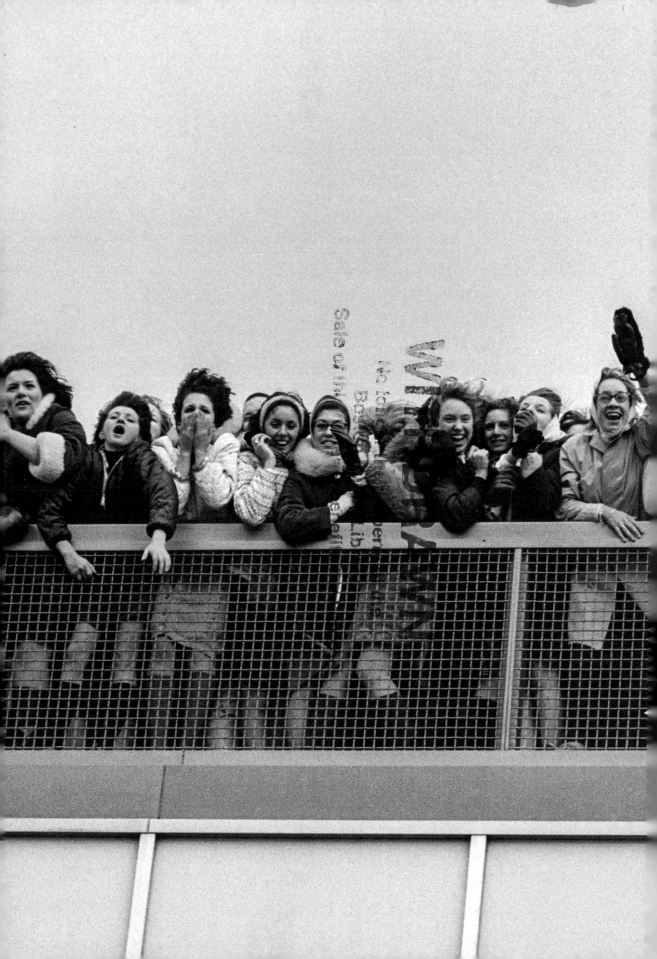